This *Was* New Jersey

This *Was* New Jersey

AS SEEN BY
PHOTOGRAPHER HARRY C. DORER

EDITED BY JOHN T. CUNNINGHAM
•
ANDREW H. BOBECK, ILLUSTRATIONS EDITOR

RIVERGATE BOOKS
An imprint of Rutgers University Press
NEW BRUNSWICK, NEW JERSEY, AND LONDON

✝

The publication of this book was made possible, in part,
by a grant from the New Jersey Council for the Humanities.

Library of Congress Cataloging-in-Publication Data
This *was* New Jersey as seen by photographer Harry C. Dorer /
edited by John T. Cunningham ; Andrew H. Bobeck, illustrations editor.
p. cm.
ISBN-13: 978-0-8135-4039-9 (hardcover : alk. paper)
1. Photojournalism—New Jersey. 2. Dorer, Harry, 1885–1962.
I. Cunningham, John T.
TR820.T498 2007
779.'99749—dc22
2006024863

A British Cataloging-in-Publication record for this book
is available from the British Library.

TEXT DESIGN AND COMPOSITION BY JENNY DOSSIN
Manufactured in China

To Charles F. Cummings

Contents

Acknowledgments

THIS BOOK HAD ITS GENESIS in the summer of 2005 when Charles F. Cummings began assembling in the Newark Public Library a major exhibit of the work of the late photographer Harry C. Dorer, whose work had brightened the pages of the *Newark Sunday Call* and the *Newark Sunday News* for more than forty years between about 1920 and 1960. This book concentrates on his work in the 1920s and 1930s.

Richard Koles, a fine photographer in his own right, volunteered to copy and prepare more than four hundred Dorer images for the exhibition. Another volunteer, Elizabeth Del Tufo, prepared some captions and other exhibit needs. Brad Small of the library staff helped assemble the exhibit and made photos accessible. Wilma Grey, director of the Newark Public Library and a strong backer of Cummings's many library exhibitions, lent her support for publication of this book of Dorer photographs and granted Rutgers University Press rights to publish the material provided full credit was given to the library and the Dorer exhibit.

Jane Brailove Rutkoff, the executive director of the New Jersey Council for the Humanities, suggested that the exhibit of Dorer's photographs merited a book and prepared the way for its publication by the Rutgers University Press.

Andrew Bobeck, a specialist in restoring photographs, transformed Koles's sepia-toned photos into the crisp black-and-white images in this book, as close as possible to the original prints that Dorer would have produced from his negatives.

Marlie Wasserman, the director of Rutgers University Press, accepted the challenge of turning the Dorer exhibit into a work of photographic art. The task of assembling the photos and copy and preparing the book for production was deftly accomplished by Christina Brianik, assistant to the director at Rutgers University Press.

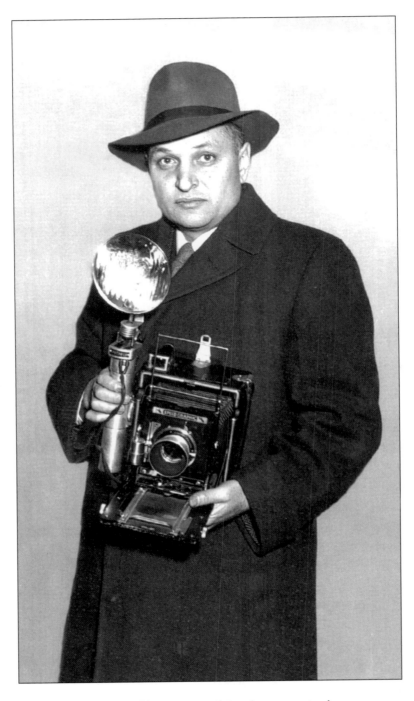

Harry C. Dorer and his trusty Speed Graphic camera, in about 1940.

What Harry Dorer
Did for Me

Harry C. Dorer opened my eyes, my ears, and my sensitivity to New Jersey in the spring of 1947. As a longtime reader of the *Newark Sunday Call*, I well knew of his entertaining and perceptive camera eye on New Jersey as featured in the *Call's* weekly rotogravure section. In 1947, the *Call* and its "roto" (rotogravure) magazine had just been acquired by the newly established *Newark Sunday News*.

(Rotogravure, for the great numbers of people who never heard the term, was a complicated offset printing process used by many newspapers to produce Sunday magazine sections. The word is best known through the Irving Berlin song "Easter Parade," sung by Judy Garland and Fred Astaire in the 1941 film of the same name. It suggested that splendid attire in an Easter Sunday promenade might get one's picture in "the rotogravure.")

When I met Harry, my achievements as a city staff reporter for the *News* amounted to little more than dashing to minor fires and taking down obituaries over the telephone. Our personable elevator operator, Jimmy, was better known than I. Then, by chance, I was assigned to do a summer-long series, called "Let's Explore," for the new *Sunday News Magazine*.

By equal—and far more important—chance, Dorer was assigned to be my photographer. My jaundiced attitude toward New Jersey was far overbalanced by Harry's ebullient love of the state.

He was already a legend. One of our respected writers, Josephine Bonomo, came back awed after a trip to the Pine Barrens with Harry as her photographer and guide. She told of Harry's bouncing his car down an ever-narrowing sandy road until they came to a clearing in what she felt was a vast wilderness.

Harry stepped out of the car as a man emerged from his woodland shack

to peer at the visitors. Suddenly the man broke into a loud laugh and shouted, "I'll be damned! Harry Dorer!" Harry explained that he had visited the man about twenty years previously.

Our first "Let's Explore" episode took us to Sussex County, then known mainly for having more cows than people and far more dirt roads than highways. I became convinced that Harry knew the first name of every cow and the last name of every human in the county. Sussex was his most beloved county.

Before our first season together ended, we had visited the peach growers of Cream Ridge, the muskmelon growers of Cape May County, the history-filled county seat of Morristown, the vast Pine Barrens of southern New Jersey, many scenic and historic spots along a back route from Morristown to the Jersey Shore, and a dozen or so other vibrant attractions of New Jersey. Between trips, I spent the hours in libraries across the state, absorbing as much local history as I could. "Let's Explore" became far more than a mere excuse for Sunday drivers to travel roads where they were not likely to encounter traffic.

Harry led the way. I chose the specific areas we would explore, based on our discussions of places worth seeing. He always drove, probably because the *News* paid employees eight cents per mile on an expense account. We traveled on byways that were not on ordinary maps. We stopped at historic sites that I knew only from my reading. Harry had usually been there before. By summer's end, "Let's Explore" was an established favorite with readers and my education in New Jersey's history and natural beauty was past the primary stage.

As we rolled across the state on the back roads, Harry told me, in bits and snatches, about his life. He was born in 1885; his first real job was with Underwood & Underwood in New York, where he apprenticed with experienced photographers and learned the skills of using a heavy Speed Graphic camera that required three-by-five-inch sheets of hand-packed film. He believed, for his entire career, that no camera was better than the bulky Speed Graphic.

Dorer joined the *Sunday Call*'s photography staff in 1919 and became well versed in New Jersey's past and present. He was prepared when the *Call* instituted its rotogravure section in the 1920s. Initially, he was the only photographer on the roto staff. Thereafter, nearly every prime assignment went his way.

"Let's Explore" continued for several years, giving me ample time to learn at the side of Harry Dorer, professor-without-portfolio. As my own research continued, I began telling Harry things even he did not know about New Jersey. It became obvious to editors that Harry and I were a good team.

The only clash that Harry and I ever had was when I told him that our

editor believed we should venture out of state to take our readers to the Poconos and the Catskill Mountains. He exploded immediately: "The Poconos? Why? We haven't even been to all of New Jersey!"

After a day of muttered recriminations for the editor, everything beyond New Jersey, and me, for being so weak as to accept miserable assignments, he finally asked, "Why should I go?"

I gave him my only argument: "The editor says we must go." And so we went. Harry was his efficient, albeit uninspired and dour self in the Poconos and Catskills. Both fitted his Speed Graphic just fine.

It is safe to say that no other journalist/ historian has gotten to know the state as intimately as I. I knew that my trips with Harry had laid a solid foundation for me when the *News* editor cut me loose to write long, detailed, and apparently intriguing articles on New Jersey's history, geography, geology, and anthropology.

In the summer of 1957, *National Geographic* recognized my skills when it asked me to write a piece on New Jersey. It became the featured article in the January 1960 issue of the magazine, with the title, "I'm from New Jersey," as if it were a confession. I felt I had earned the equivalent of another college degree.

Then, when my historical writings expanded into other types of long series for the roto section (railroads, New Jersey's twenty-one counties, the state's diversified industries, agriculture in depth, colleges and universities, as examples), I asked for Harry as my photographer whenever possible. He cared about what I was doing and understood why Rutgers University Press was turning my series into popular books, with many of the illustrations supplied by Harry. It was my privilege to dedicate my third book, *The Garden State* (a history of the state's agricultural importance), to him in these words:

To Harry C. Dorer, who set me on the road to knowing New Jersey.

Inevitably, I suppose, I played a role in ensuring that the Dorer legacy would live on. The day after Harry's death on January 26, 1962, I received a call from Irving Tuttle, another *Newark News* photographer and a warm friend of Harry and me. Irv said a distraught Mrs. Dorer wanted to dispose of Harry's files as quickly as possible.

I sped to the Dorer home in Livingston. The files included several hundred negatives and prints, more than dozen bound volumes of the *Newark Sunday Call,* and, most rewarding of all, a complete index of everything.

I immediately called the director of the Newark Public Library, who promised to send a truck to pick up the collection. The truck arrived in about twenty minutes. Thus, so simply, was the Dorer treasure saved. And between these pages is a small sampling of that treasure.

JOHN T. CUNNINGHAM

Florham Park, New Jersey
June 2006

This *Was* New Jersey

Best of the Best

EVERY PHOTOGRAPHER has his favorite prints. Harry Dorer was no exception. We can guess at his favorites from a few enlargements that he made, possibly for framing someday. Here is a selection, ranging from the animation of a trio of horses and a fire department "steamer" to the stateliness of the annual holiday concert of the New Jersey College for Women (later Douglass College) choir in Voorhees Chapel. These choices evidence his broad interests and serve as an introduction to the many of the subjects he photographed.

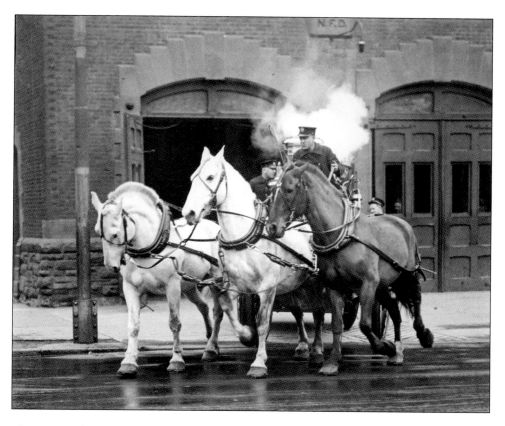

This one may have been Harry's favorite: a horse-drawn fire engine is a dramatic remembrance of the past.

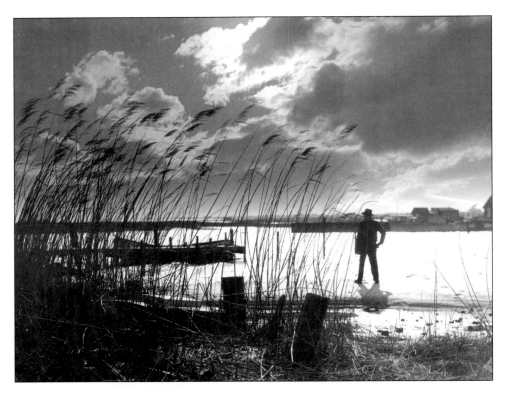

Barnegat Bay marshlands darkened as storm clouds rolled in during the twilight hours.

FACING PAGE: *A steeplejack at the top of the Trinity Church steeple in Newark urges his helper to look upward to see the biplane passing in the sky above.*

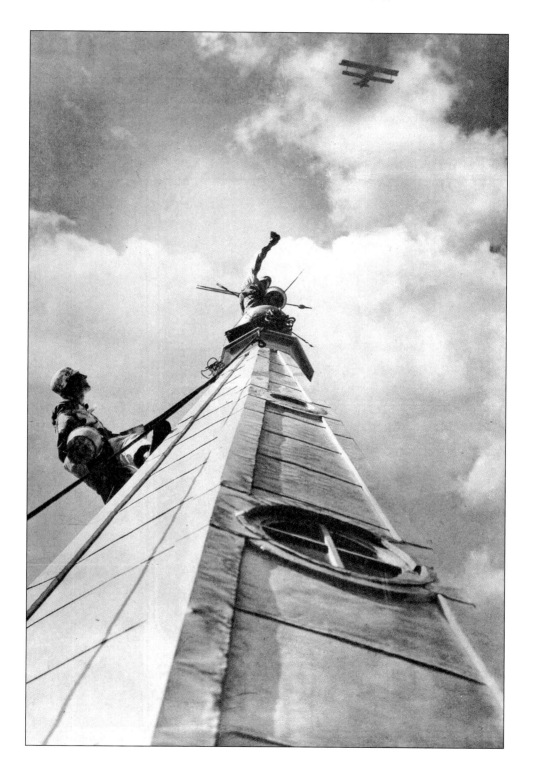

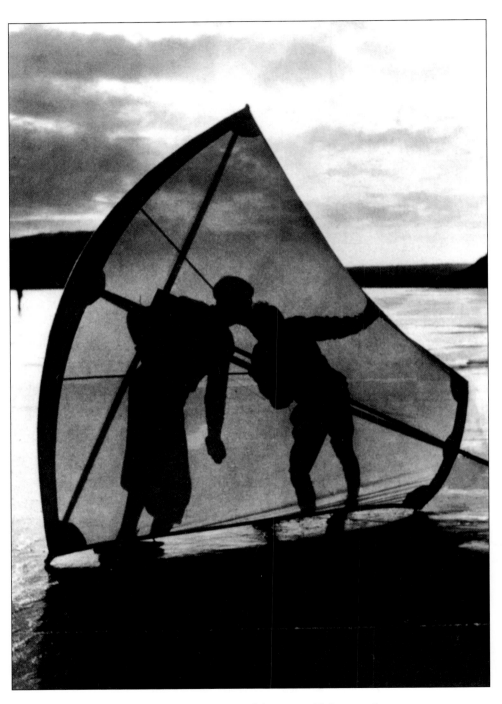

An iceboat on a northern New Jersey lake is an unlikely venue for romance.

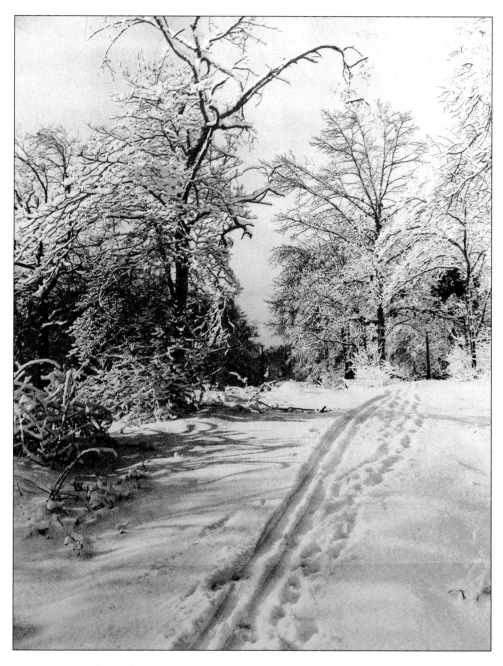

Winter snow in the South Mountain Reservation in Essex County, only a few miles west of Newark, marked by the tracks of a cross-country skier accompanied by someone willing to walk.

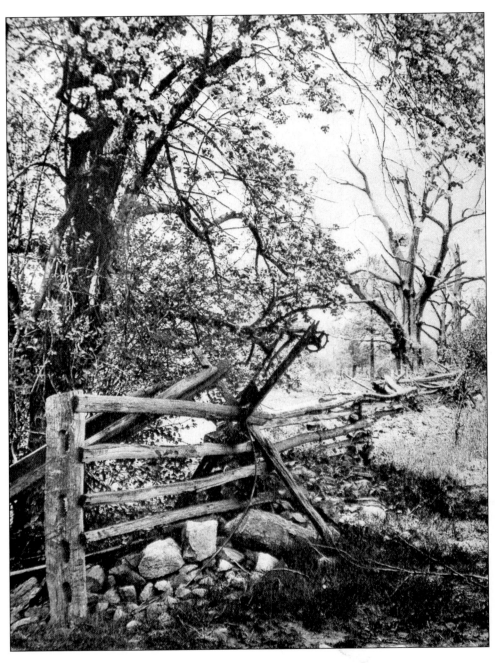

A rambling country fence, most likely in Morris County, told of longevity and serenity.

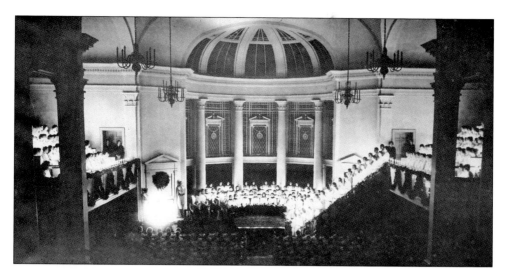

Harry rigged up several floodlights to provide a beguiling setting for a photo of the annual Christmas program in Voorhees Chapel at the New Jersey College for Women (later Douglass College) in 1935.

Two British children, refugees of World War II, watch as their little brother writes a letter to Santa Claus.

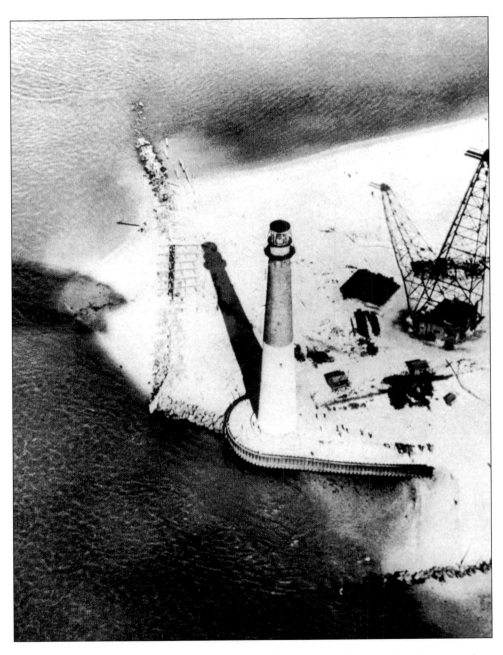

Barnegat Lighthouse, taken in the late 1930s, combined Harry's love of soaring above the Jersey Shore in a navy blimp with his keen sense of the right moment to take a photo.

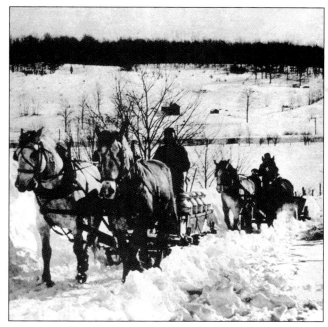

Winter delivery of Sussex County milk was by horse-drawn sleigh.

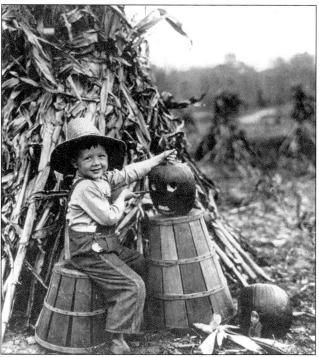

A good-looking boy, cornstalks, and a carved pumpkin: no cameraman could resist that shot.

Harry occasionally dipped into his files to show Sunday Call *readers a historic moment, as here, the pageantry in Newark on Armistice Day in 1918. The building of skyscrapers had not yet begun.*

Newark: Dorer's Beginnings

UCH OF Harry Dorer's fame came from his wanderings through the farmlands, the Pine Barrens, and New Jersey's hinterlands, but his taproot was Newark. In Harry's era, it was far and away New Jersey's largest, most prestigious, and most prosperous city, and it was also the headquarters of the *Newark Sunday Call,* his employer.

He often roamed the streets of the city, looking for good photo essays. He would climb out on the steel girders of unfinished skyscrapers or trudge through the mud of the Newark subway construction. A distillation of those wanderings is found throughout the pictures that follow.

In the twenty years of Harry's greatest productivity, from 1920 to 1940, Newark changed from a small, unremarkable city into an important financial, industrial, and cultural center. The airport and seaport would overcome discouraging starts to be leaders in both air traffic and sea tonnage. Harry Dorer did not bring the transformation about, but he recorded it.

During the 1930s, Harry often portrayed Newark's ever-rising Broad Street, in this instance as viewed from Washington Park southward. Superimposed over the city is the masthead of the Newark Sunday Call's rotogravure magazine.

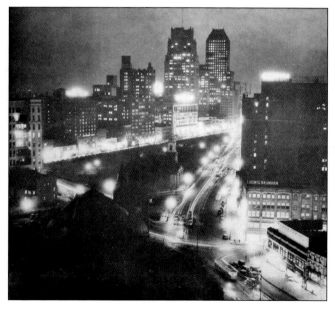

As late autumn brought early darkness, Harry captured the heavy exodus of commuters by following their headlights on Broad Street and on the far side of Military Park.

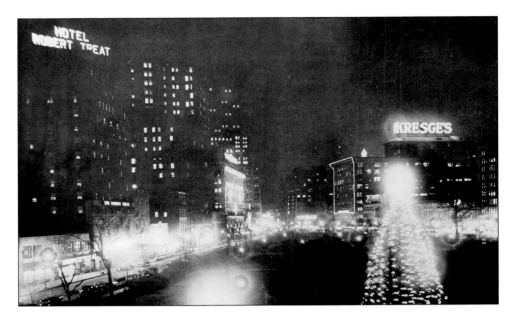

Christmas lights each year brightened downtown. The top-flight Robert Treat Hotel and the prospering Kresge's Department Store stood out. Kresge's main rivals, Bamberger's and Hahne's, were farther downtown.

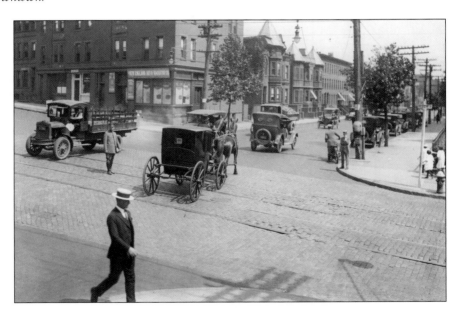

This was one of Newark's busiest intersections in 1922—a mixture of horse-drawn buggies, automobiles and trucks, streetcar tracks, and pedestrians. Driving on the city's streets was easy: automobiles had not yet come into dominance.

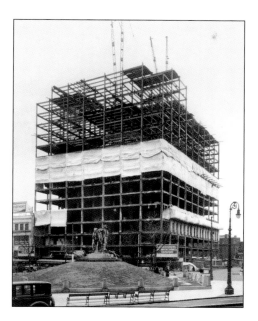

The skeleton of New Jersey Bell Telephone Company, as it appeared in 1926, began Newark's reach for the skies. Note how the building dwarfs the statue of Washington and his horse in the park across the street.

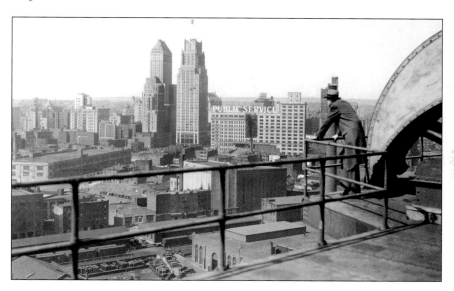

Newark's tallest building, the thirty-five-story National Newark & Essex structure (with the pointed top), completed in 1931, rose one story higher than the Lefcourt Newark giant (now the Raymond Commerce building) finished in 1930. Both, along with Public Service (now PSE&G), appeared in this view from atop the Pennsylvania Railroad lift bridge.

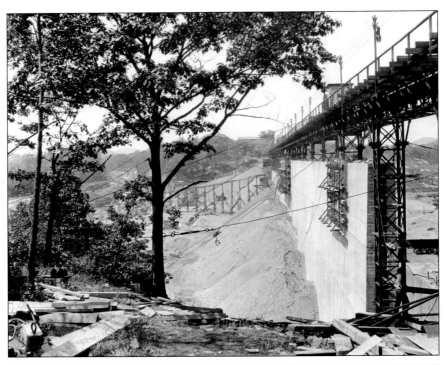

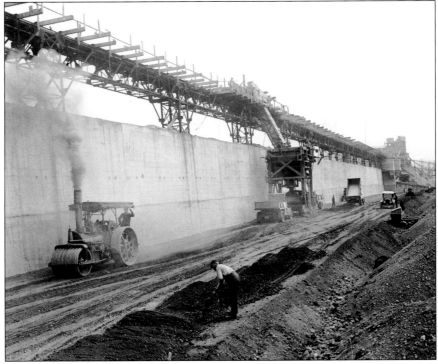

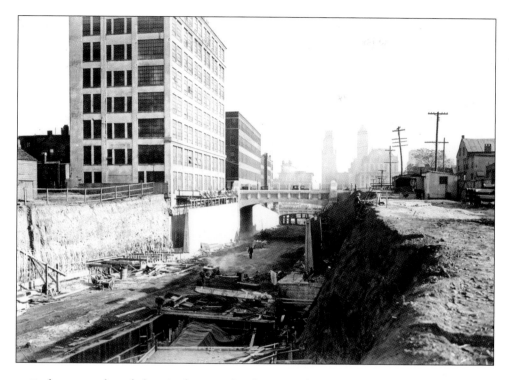

In the city, work sped along on the Newark Subway, overlain in part by Raymond Boulevard.

FACING PAGE:

TOP: *The rapid population increase and the need for clean water forced Newark's leaders to build the Wanaque Reservoir in the late 1920s. The massive dam stretched across a Passaic County valley.*

BOTTOM: *A front view of the mighty Wanaque dam under construction.*

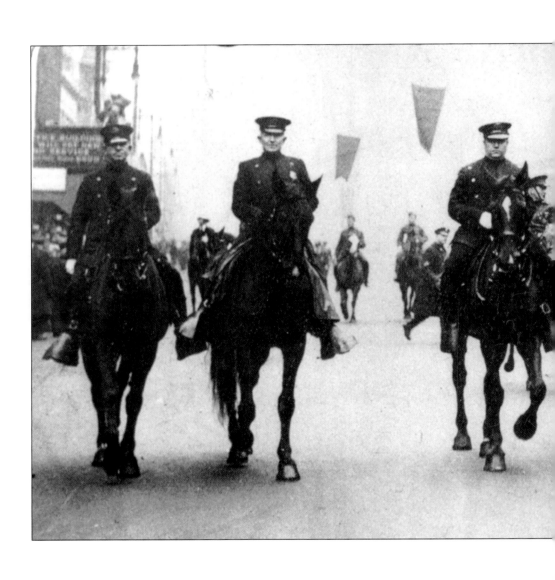

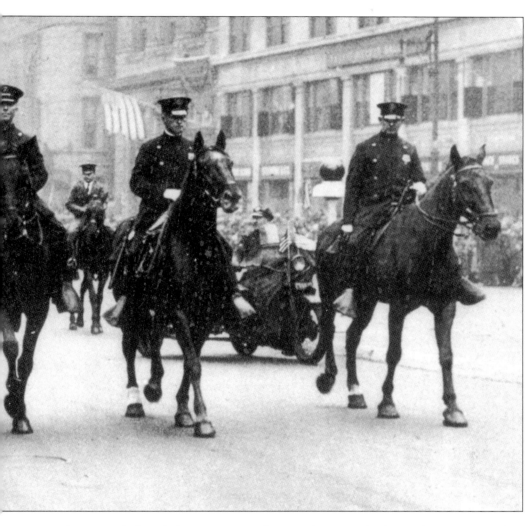

Leading a parade through the city's streets in the 1920s, the mounted police made an impressive show of power.

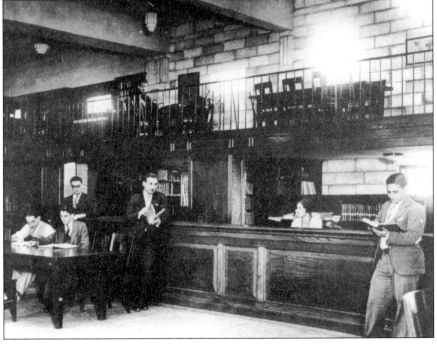

A major change came to Newark with the beginning of Newark University in this abandoned Bal-
lantine's Brewery at 40 Rector Street. From this humble start would grow what is now the sprawling
Rutgers University campus in Newark.

FACING PAGE:

TOP: *The trained mounts on work days were excellent for patrolling such difficult, spread-out areas as
the recently opened Newark Airport.*

BOTTOM: *Inside the brewery building, students with a "thirst for knowledge" (Harry's pun) gathered
in the area converted into a college library.*

CHAPTER THREE

Newark's Diverse People

I N 1941, on the eve of America's involvement in another world war, Harry
Dorer roamed Newark for several weeks, seeking to capture glimpses of the
city's many ethnic groups. He visited Newark's Chinatown, then a distinct
area. He paused in the city's colony of Moors and attended meetings of Ukrain-
ian and Greek societies. He depicted not only the large German and Italian sec-
tions but also found Filipino and Spanish enclaves. He sought to get photos that
would both document and honor the many nationalities represented in the city

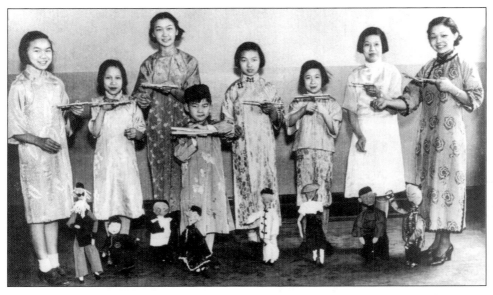

Chinatown's younger set presented an East Asian version of Aladdin and his magic lamp.

FACING PAGE:

TOP: *A young Italian woman demonstrated the skill of drying peppers for winter use.*

BOTTOM: *High-stepping young Polish women danced the polka in Falcon Hall on New York Avenue.*

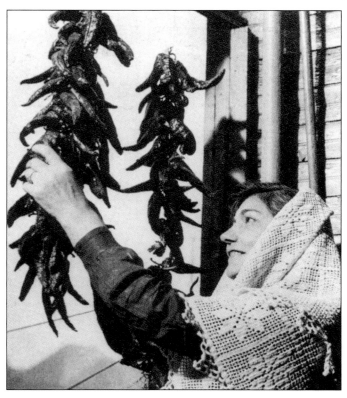

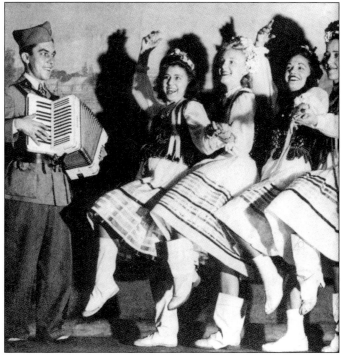

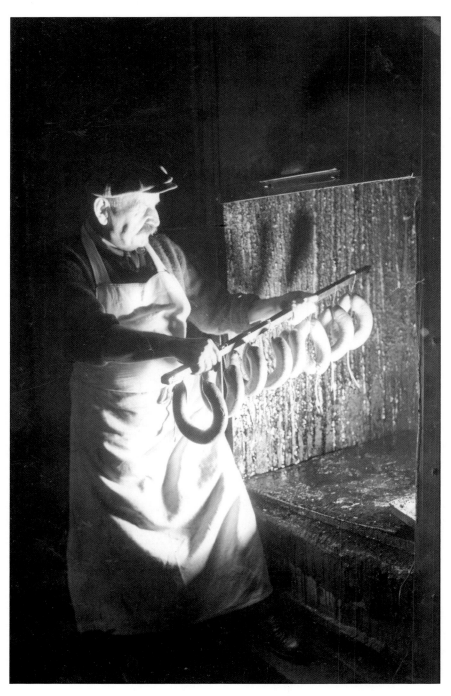

A veteran German bologna maker showed how genuine mettwurst is taken from a special smokehouse.

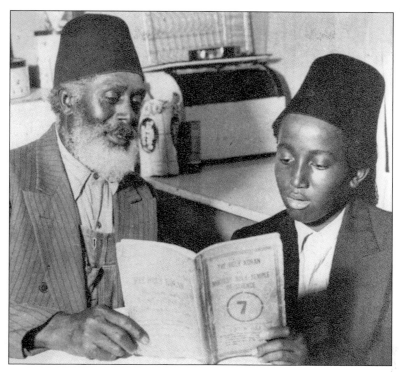

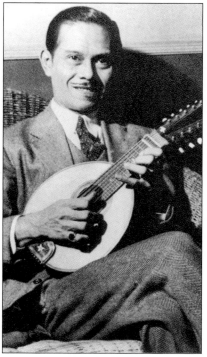

TOP: *The Third Ward's 600 Moorish Americans observed ancient traditions, such as the teaching of the Holy Koran.*

BOTTOM: *A Filipino American played the kind of guitar that was familiar in his native land.*

A señorita who called Newark home posed in a Spanish Manola costume that in her native land can be worn to church or to a bullfight.

Evoking sentiments of their homeland, a Ukrainian couple harmonized a song usually followed by a Cossack dance.

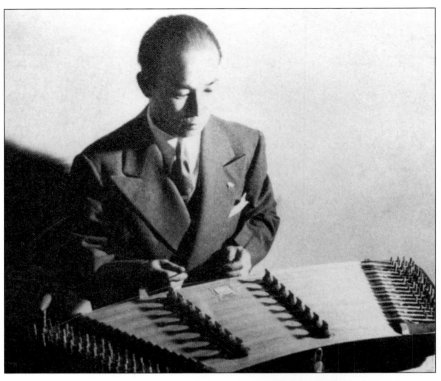

TOP: *A Chinese American played an ancient harp in Newark's Chinatown.*

BOTTOM: *Nargiles, a Turkish pipe, was popular with Greeks in their Newark clubhouse.*

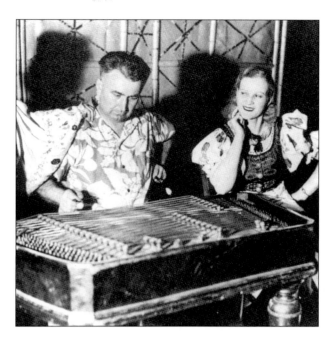

Instead of a bulky piano, these Hungarians used their national instrument the czimbalom for their accompaniment.

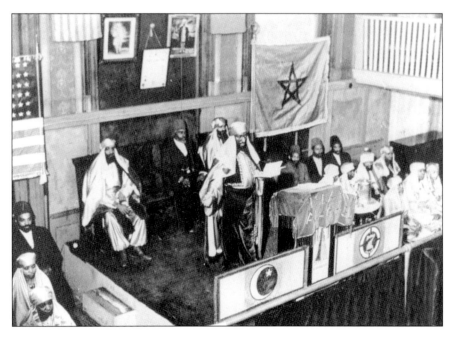

The Moorish American community held Friday night services at its Court Street temple.

CHAPTER FOUR

A Voice for the Farmlands

H ARRY DORER RELISHED driving over the dirt or gravel roads that in the 1920s and 1930s bordered the dairy pasturelands of Sussex and Warren counties, Hunterdon's chicken farms, Monmouth's apple farms, Gloucester's peach orchards, and astonishingly long rows of vegetables in Cumberland. Harry did not invent the New Jersey nickname, "The Garden State," but he made it visible.

If the Newark photographer could have lived his life over, he probably would have been a New Jersey farmer or a spokesman for the State Department of Agriculture. He proclaimed nothing was more wondrous than Sussex County's corn, Cape May's melons, Gloucester County's apples, Warren County's milk, Freehold's white potatoes, Cream Ridge peaches, and widely grown Jersey tomatoes—which he *knew* were the best in the world.

Each year he photographed farm activity ranging from digging in Monmouth County potato fields to sorting fruit and loading vehicles. He always brought baskets of vegetables and fruit back to ensure that "the girls" in the office knew the meaning of "Jersey Fresh."

Mechanized farms were rare; nearly 60,000 horses were working on farms in 1925—and few subjects attracted Harry more than powerful horses pulling plows or reapers. By the late 1940s, the transformation to motor power was a reality—and Harry began photographing field machines with the power of a hundred or more horses.

In 1930, nearly 125,000 cows were milked daily on about 16,000 New Jersey farms. Harry proudly recounted that Sussex had "more cows than people." He was right.

One of the dirt or gravel roads common in New Jersey farm areas. In 1925, there were about 13,000 miles of such roads in the state.

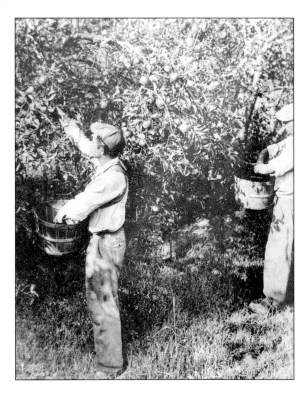

The rough roads ran past sprawling apple, peach, and other fruit orchards in nearly every county.

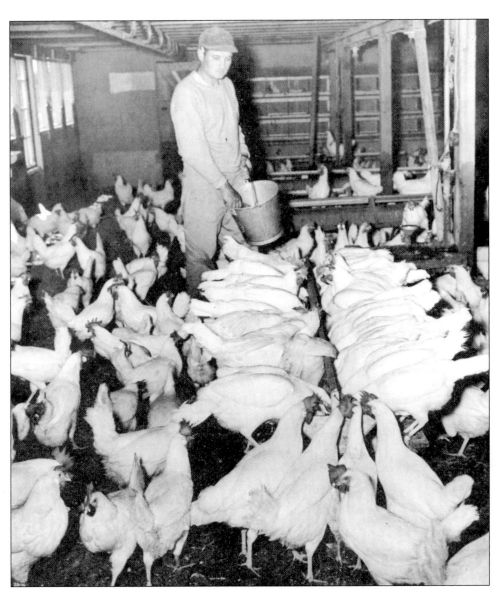

Poultry farms, particularly those featuring white leghorn hens and their eggs, were major sources of farm income.

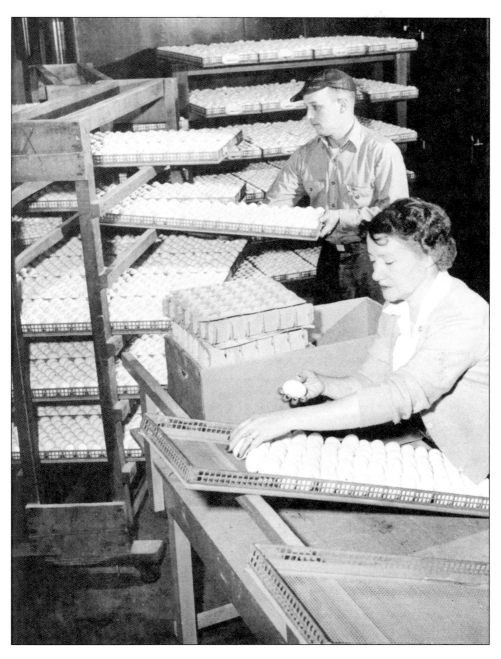

By 1930, New Jersey hens laid more than a million dozen eggs annually.

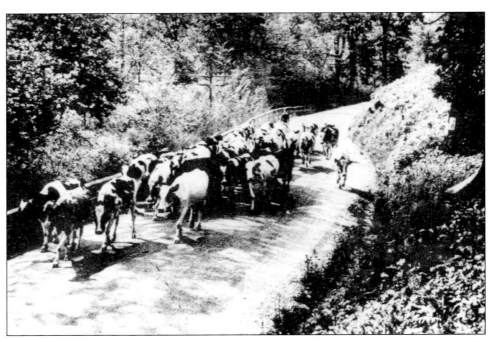

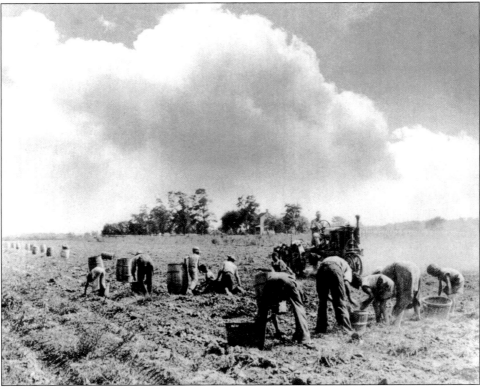

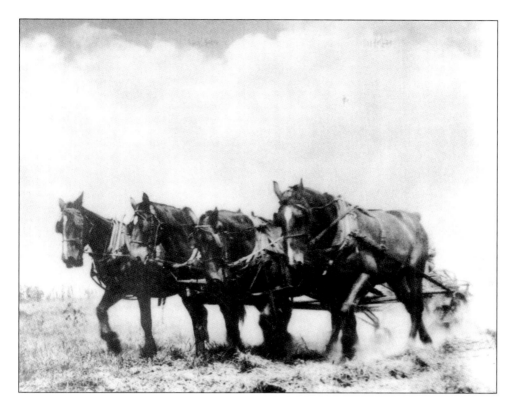

Nothing appealed to Harry more than the workhorses on nearly every farm. Sixty thousand horses provided most of the state's farm power in 1925.

FACING PAGE:

TOP: *Twilight in Sussex, Warren, Hunterdon, Burlington, Cumberland, and nearly every other county found roads blocked by cows heading to barns to be milked.*

BOTTOM: *Migrant workers were ever-present in summer. They plucked vegetables from southern New Jersey fields, dug potatoes in loamy soil across the center of the state, and harvested fruits in season.*

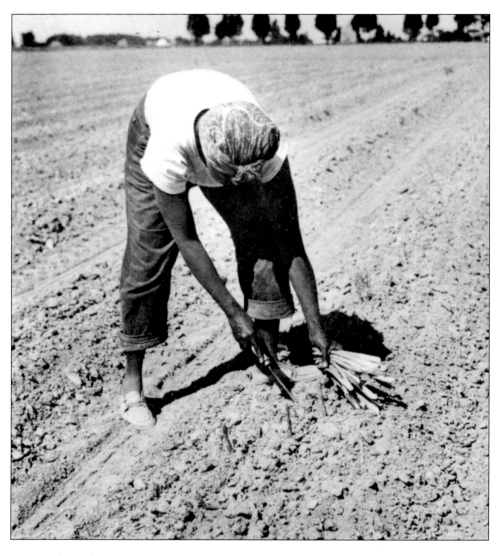

No farm job was more arduous than a day of leaning over to cut asparagus, stalk by stalk.

FACING PAGE:

TOP: *Mercer, Middlesex, and Monmouth Counties in the 1920s produced nearly four million to five million bushels of "Irish" (white) potatoes annually.*

BOTTOM: *Big potatoes made for good poses. These boys worked in their family's fields.*

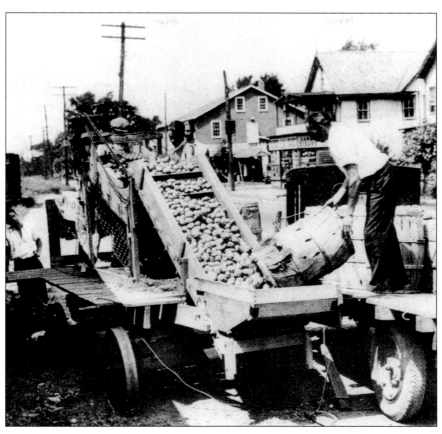

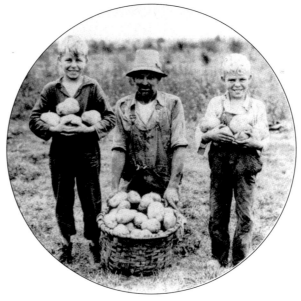

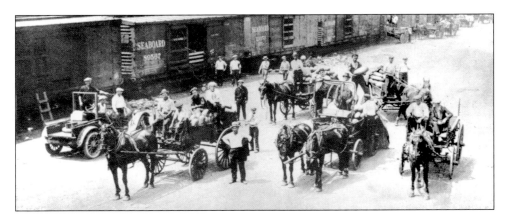

Special watermelon trains ran in and out of Kearny's railroad yards and, in season, carried other vegetables and fruits to market.

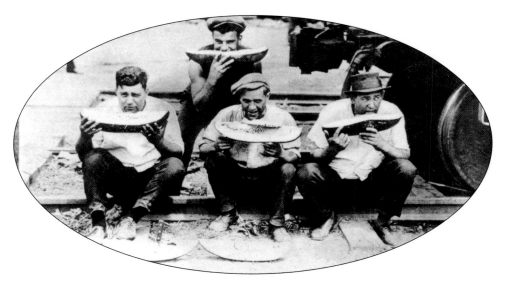

Workers at Kearny occasionally "found" a lost melon. One quenched the thirsts of four men.

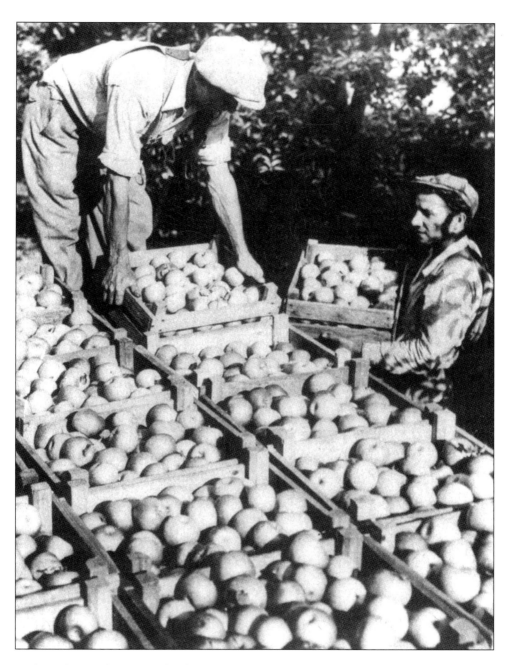

By the mid-1930s, the state's orchards produced nearly 2.5 million bushels of apples annually, enough to keep many a doctor idle.

Workers were credited six cents for each bushel of apples picked, packed, and brought to the paymaster. An experienced packer filled 100 barrels a day.

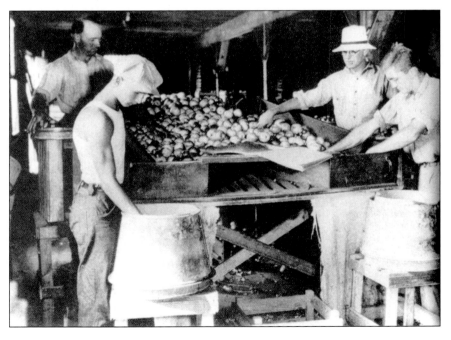

Apples, like all other fruits, were hand-inspected to ensure no bad apples got into any basket.

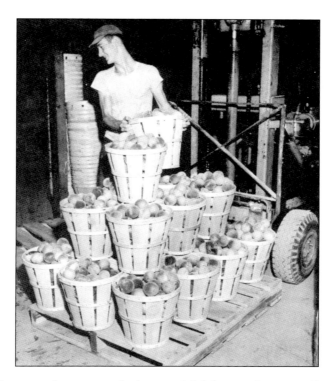

By 1939, about 1,400 farms reported a harvest of slightly more than one million baskets of peaches. More than twenty-five peach varieties were popular.

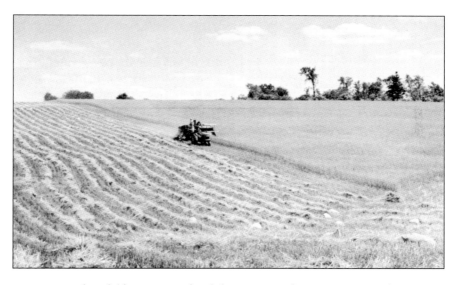

New Jersey's wheat fields were astonishingly large. In 1935, about 60,000 acres in the state produced 1.3 million bushels of wheat annually.

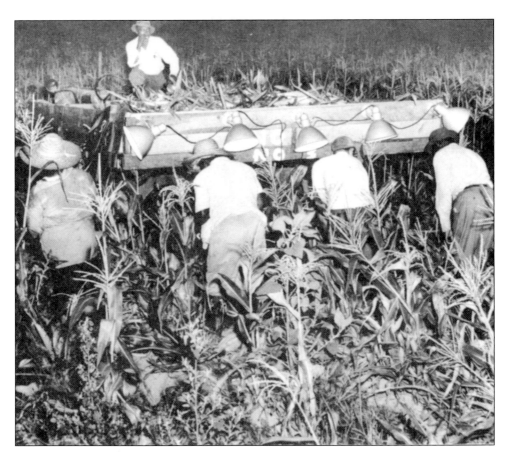

By 1940, Jersey sweet corn, white and yellow, was so popular that picking started in the predawn hours under floodlights.

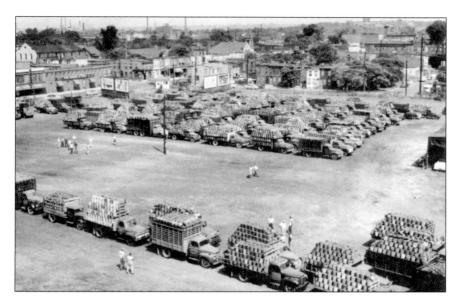

Campbell's Soup Company in Camden built its national reputation on New Jersey tomatoes. Here long lines of tomato-laden trucks roll into Camden in season. Catsup factories in southern New Jersey added to the demand.

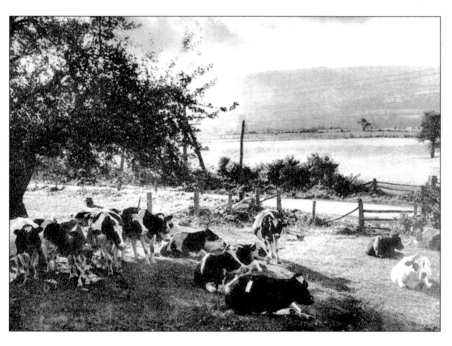

Twilight brought a pastoral peace to the farms as cattle bedded down for the night.

Far from the City Streets

As a roving photographer of the 1920s and early 1930s moved into the hills west of Morristown or across the coastal plain southeast of Trenton, Harry Dorer entered a different world: rural New Jersey. Few farms had electricity, much less telephones. Most homes were small and poorly built. Indoor plumbing was scarce; outhouses appeared behind nearly every home. Living was neither easy nor comfortable.

Farmers milked their cows by hand, by the light of kerosene lanterns. Many farmers did not have an automobile or a tractor; teams of horses provided most of the power and transportation needs. Children went to school in one- or two-room buildings—with one teacher for grades one to eight (there were no kindergartens and very few high schools in rural New Jersey).

State Police were a welcome sight. In an area of little crime, they performed a variety of social needs. Organized in 1921 with 81 officers and troopers to provide protection to off-the-beaten track villages and farms, the police did everything from visiting schools to teach safety to dropping in on older people to assure them help was always near—and, if they had spare time, they checked on summer homes on the lakes and in the hills during off seasons. Seventy years later, when rural areas were disappearing, the force had 2,600 troopers and 1,000 civilian employees.

FACING PAGE, CLOCKWISE FROM TOP:

This cabin was indeed "rural" but it was not in the backwoods. This home of James Whitehead was on well-traveled Neshanic Road in the Sourland Mountains of Hunterdon County.

Mrs. Rebecca Docherty, who in 1935 proudly told a visitor she had lived all of her eighty-nine years in the same Sourlands home.

Harry was invited to stay for a country lunch, fried on a wood-burning stove.

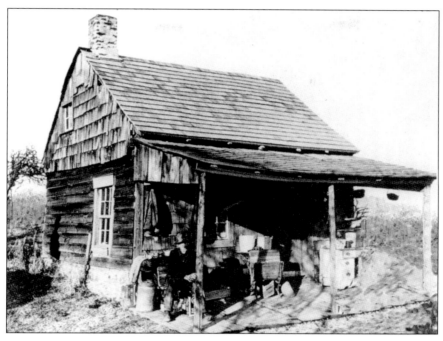

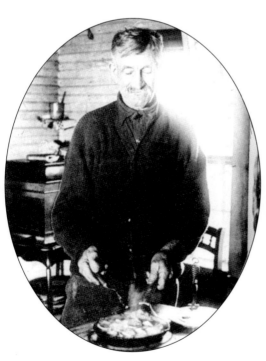

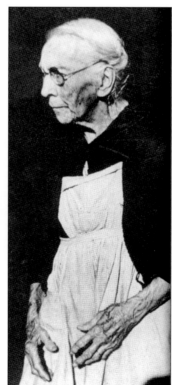

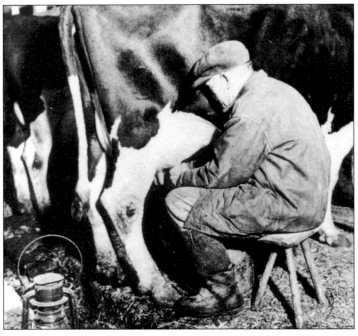

TOP: *Anyone hoping to see a Sussex County farmer milk a cow by hand had to be in the barn before a rooster greeted dawn. Note the kerosene lantern in the lower left corner.*

BOTTOM: *The morning milk was poured into metal cans, then surrounded by ice to keep it fresh.*

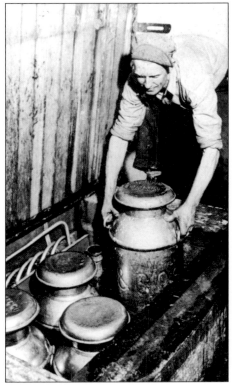

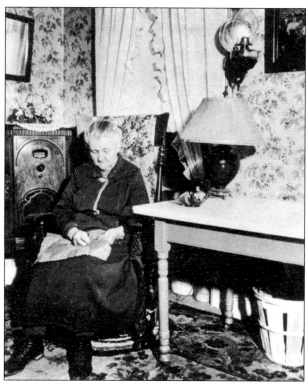

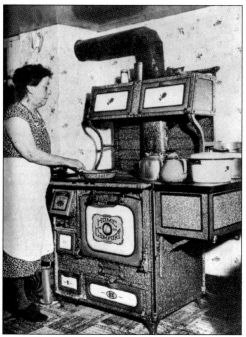

TOP: *Wonderful electricity reached the far reaches of Sussex County in the late 1930s via the federal Rural Electrification Administration, providing light for Jennie Post's embroidery and a big radio to bring Rudy Vallee and "Amos 'n' Andy" into her Harmony Vale home.*

BOTTOM: *In time the Posts would have an electric stove, but in 1940 the big kitchen coal range was sufficient for fine cooking.*

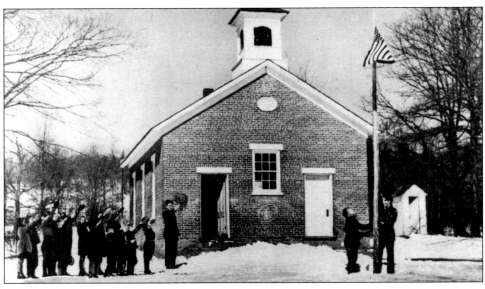

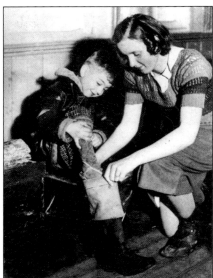

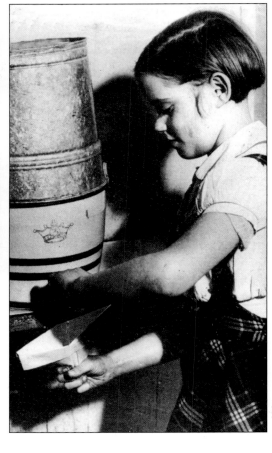

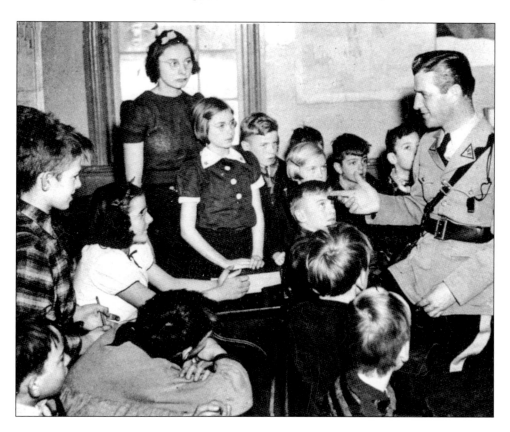

Occasionally a state trooper dropped into the school to tell the serious boys and girls about possible "crime" in Swartswood.

FACING PAGE:

TOP: *Scores, if not hundreds, of one- and two-room schoolhouses stood on rural corners in New Jersey in the 1930s. This one was in Swartswood, part of Stillwater Township.*

BOTTOM LEFT: *Swartswood's teacher did everything—taught all subjects, supervised the playground, presided over lunch, listened to children's woes, and, very importantly, helped her little charges put on their boots.*

BOTTOM RIGHT: *A student enjoyed a drink of water at the less-than-modern cooler.*

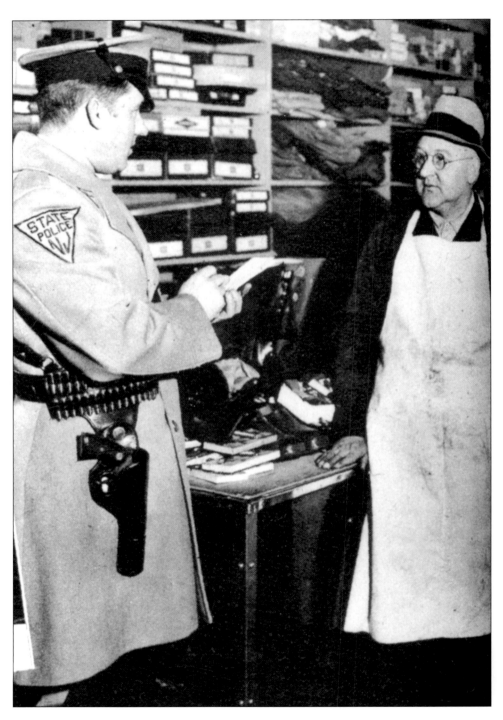

Outward from the school, a handsome young trooper visited a storekeeper . . .

. . . Checked locks on summer homes . . .

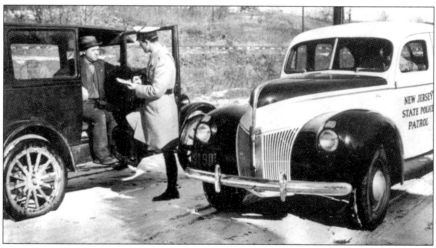

. . . Talked to a motorist about road conditions . . .

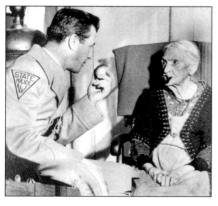

. . . and shared an apple with an elderly hostess while seeing if there was anything she needed, especially some tobacco for her pipe.

The Pine Barrens

No part of New Jersey captivated Harry Dorer more than the Pine Barrens in the southern part of the state. In the 1920s and 1930s the Barrens comprised considerably more than one-fifth of New Jersey. Commercial building has since eaten away at the edges, but state and federal laws now protect the area; it still occupies about a fifth of the state.

Seldom has an area been so misnamed. Early settlers bestowed the name "barrens" because the soil would not grow the usual crops of wheat and pastureland grass. The forest is mainly pitch pine, but scrub oaks can be found in many places.

At least 400 species of wild plants thrive beneath the trees, including about 35 different kinds of wild orchids. More than 150 species of rare frogs, flying squirrels, deer, muskrats, beaver, and several species of harmless snakes live in the Barrens.

The chief reason for preserving the Pinelands, however, is an estimated 17 trillion gallons of clean, pure water in natural aquifers beneath the surface. There is no more precious commodity.

Harry knew much of that, but he returned to the forest again and again mainly because he liked its inhabitants and they liked him. He drove deep into dense woodland to photograph the "Pineys," a once-feared group that he knew were friendly but shy and suspicious of outsiders.

Harry made the Pineys understandable through his many photographs. His favorite times to visit were in summer when huckleberries were being harvested, and the fall, when the Pineys picked cranberries. Most of the photographs in this section were taken in 1924. To an urban dweller perusing the *Newark Sunday Call* rotogravure, the Pineys must have seemed like survivors from another era.

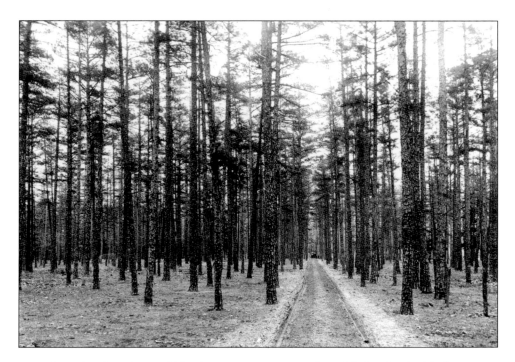

A sandy road such as this would be the invitation to enter a forest filled with colorful place names such as Double Trouble, Apple Pie Hill, Indian Mills, Prospertown, Red Lion, Blue Anchor, and Penny Pot.

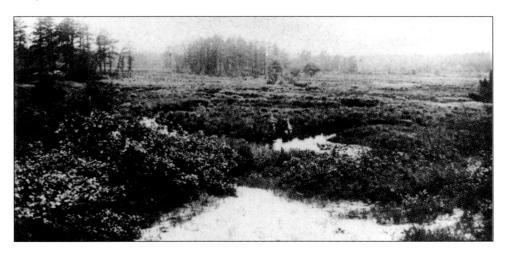

Pine Barrens visitors passed huge cranberry bogs such as this, said to be "the largest cranberry bog in the world."

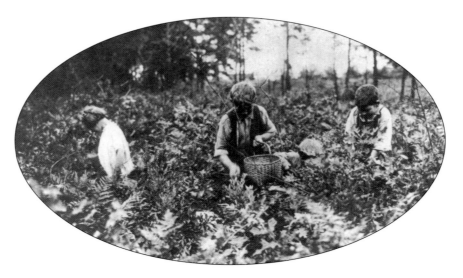

In early summer, shy children busily picked wild huckleberries (not blueberries, they told visitors).

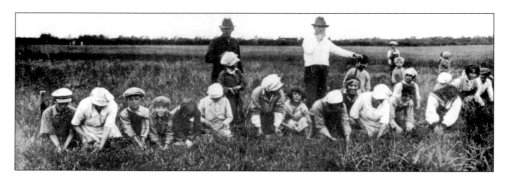

In the fall, children would pick cranberries.

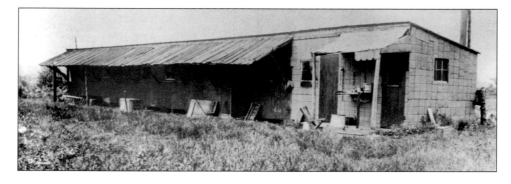

Occasionally, openings in the forest revealed a weathered home. "Indian Kate," a well-known Pinelands character, owned this building. Itinerant pickers occupied the long dark shed in cranberry season.

Austrian scientists used this plain building as headquarters for studies of the sandy Pine Barrens soil. They mixed fertilizers into the sand and were said to have produced rich crops, including some vegetables previously unknown in New Jersey.

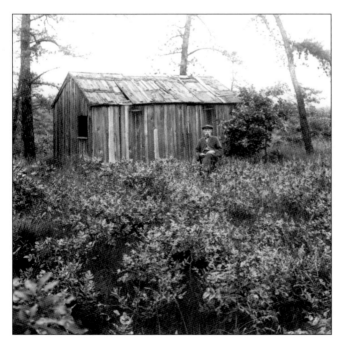

Harry loved to take curious colleagues deep into the woodland, as far as this shack where seventy-six-year-old Caleb Bennett lived most of his life. He loved cigars; it cost Harry a five-cent stogie to get Caleb to pose in his front yard.

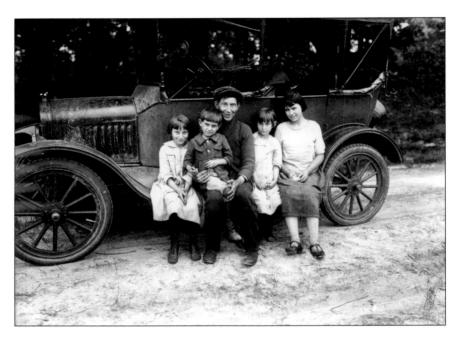

"Uncle Walter" South, his son, and three daughters of Cranberry Hall posed on the running board of the family's Ford flivver. Mrs. South, camera-shy, hid on the car's other side.

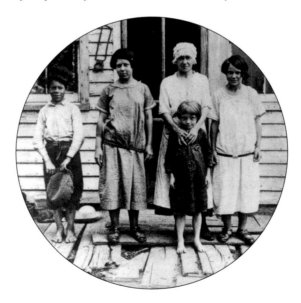

Mrs. Freeman Parl of Cookstown, wearing her fancy hat, posed with her four children on the steps of their home. The girls wore then-popular drop-waisted dresses. The boys were barefooted.

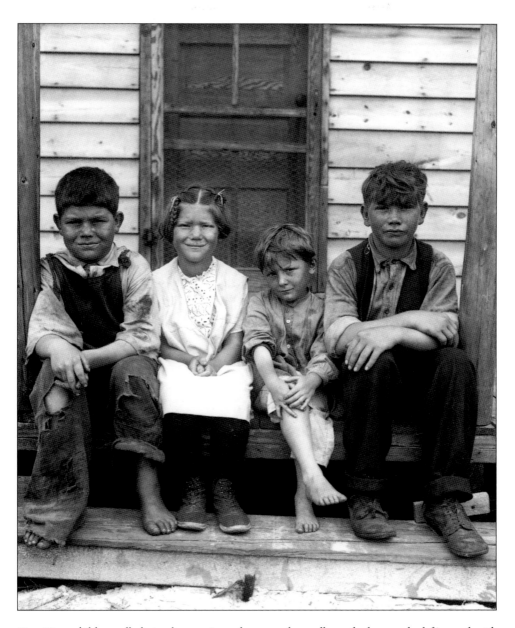

Four Piney children, all obviously poor (note the tattered overalls on the boy on the left) posed with dignity and charm.

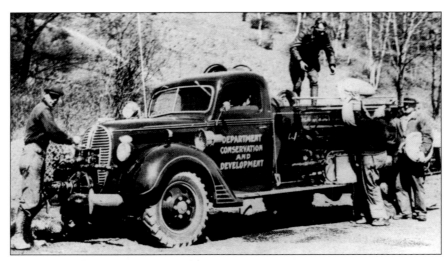

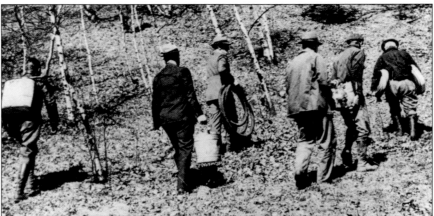

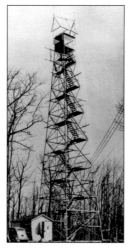

TOP: *Occasionally Harry encountered one of the great fires that have swept through the pine woodland for generations. He paused to watch as a crew from the New Jersey Department of Conservation (which administered the pinelands) assembled firefighting gear.*

MIDDLE: *The firefighters, including one in a business suit, headed over a rough path toward a fire, carrying equipment they would need.*

LEFT: *Harry climbed the ten flights of these metal tower steps to look down on the massive fire that was leaping across roads and destroying everything it touched.*

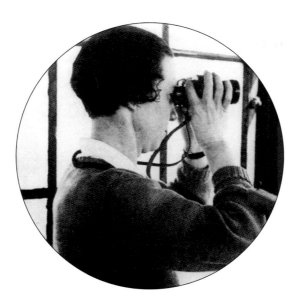

The fire warden in the tower was a female, unusual among the nearly all-male firefighters. She lent Harry her binoculars so he could follow the course of the dangerous fire below.

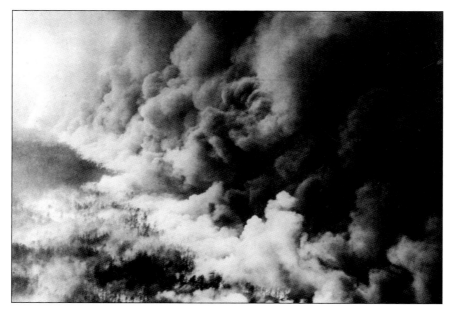

This was a big one. Billowing dark smoke hid the flames crackling through the dry pine needles, surging like a whirlwind toward more fuel. The white smoke lingered over areas already burned. During a dry spring or summer, a single Pine Barrens fire might sweep through thousands of acres before being stopped.

Over and Under New Jersey

F ASTER TRANSPORTATION became the overwhelming passion—and need—as the 1920s advanced. Harry Dorer was there as the Pulaski Skyway stretched across the Newark Meadows, linking Newark to the just-finished Holland Tunnel. He was there when the Goethals Bridge between Eliz-

abeth and Staten Island was opened in 1928. He was there in the early 1930s when the defunct Morris Canal bed was widened and deepened, creating the Newark subway. He witnessed the first stages of the building of the Bayonne Bridge from Bayonne to Staten Island in 1930; when completed, it would be the longest arch bridge in the world. And above all else, he visited the mighty George Washington Bridge as it was being completed in 1931.

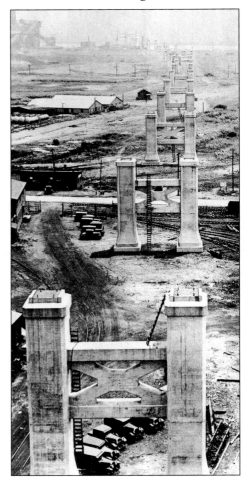

Tall, graceful concrete piers stretching high above the formidable Newark Meadows in December 1932 would support the longest viaduct of its type ever constructed to that time. It was the Pulaski Skyway, named for Count Casmir Pulaski, the Polish nobleman who fought with George Washington in the Revolution. The elevated roadway would link the Holland Tunnel with the Lincoln Highway in Newark.

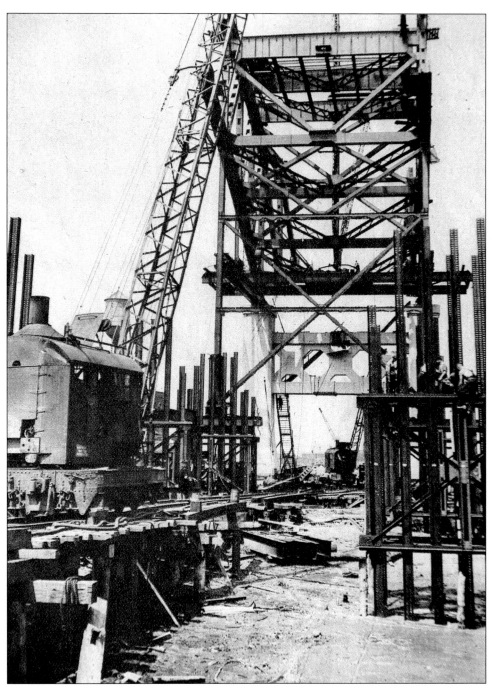

The first steel girders were in place; the 550-foot-long cantilever spans that would carry the highway across both the Passaic and Hackensack Rivers was well on course.

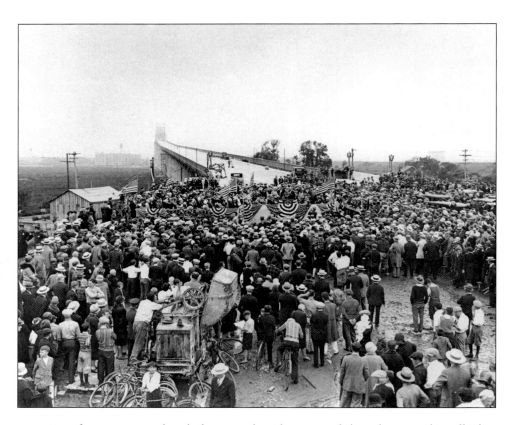

Harry was of course present when the history-making skyway was dedicated in 1932. The traffic density on the 6.2-mile-long viaduct soon surpassed even the claims of orators on dedication day.

FACING PAGE: *Harry took chances as he chronicled the impressive public works being built to span the marshes and the rivers. He is shown here on the girder to the left, higher than the men being carried upward at one of the bridges-in-progress.*

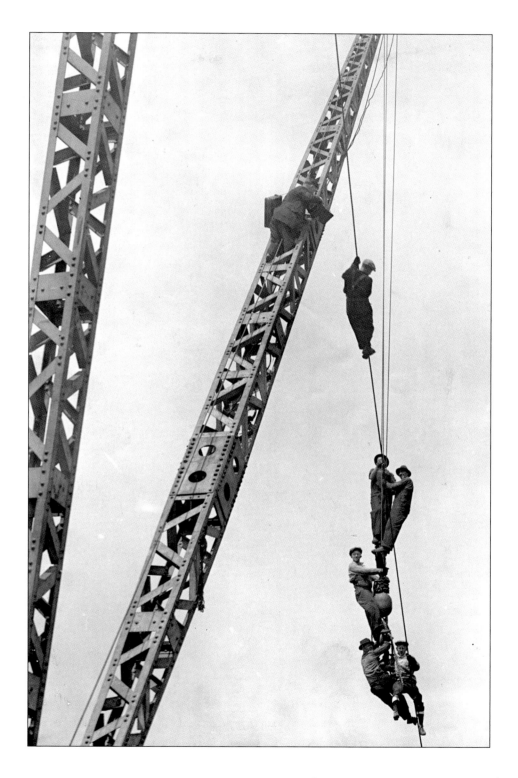

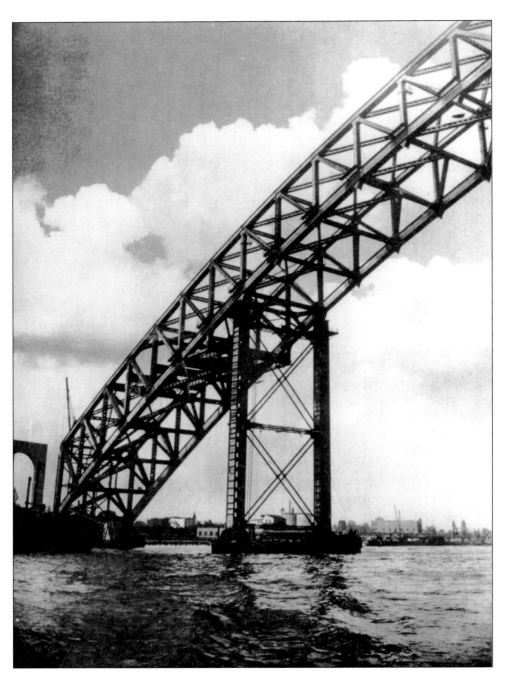

The Bayonne Bridge, linking Bayonne and Staten Island, had only advanced to the basic arch in the early 1930s. When completed, the arch would span 1,675 feet over the Kill van Kull, the waterway linking the bays of New York and Newark. It was the longest such bridge in the world.

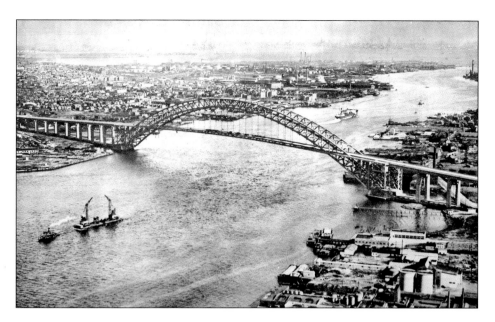

New York and New Jersey officials dedicated the Bayonne Bridge on November 15, 1931. The next day it was opened to automobiles, which immediately began using the bridge's four lanes.

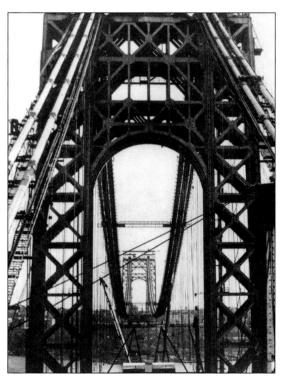

No bridge built in the 1930s rivaled the beauty and utility of the George Washington Bridge, which stretched from the high Palisades on the New Jersey side to a rocky cliff in Washington Heights on the New York City side.

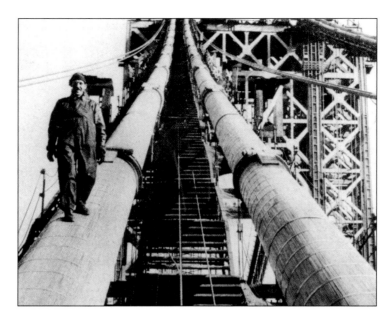

Harry was especially interested in the courage of bridge builders. He took this photo of a worker on one of the giant cables of the George Washington spans. How did Harry get this daring shot? Easy: he was up there, higher than the worker!

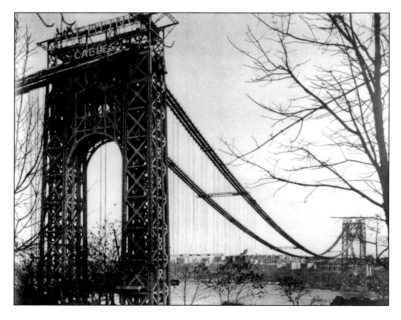

The bridge, acclaimed as the longest single span bridge in the world (3,500 feet), was dedicated in 1931 and was the major factor in the great population growth in New Jersey's Bergen County.

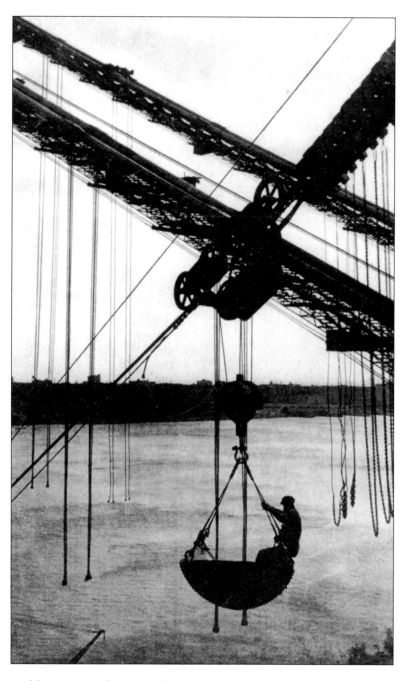

Completion of the George Washington Bridge meant that the "skip," used to transport men and materials from the top of the Palisades to the base of the Fort Lee tower, would move on to another construction job.

In December 1939, Newark officials decided to build a new roadway (Raymond Boulevard) and a rapid transit streetcar subway system. It would be done by hand rather than by machines so nearly 3,000 unemployed men could be put to work at four dollars a day. This is the view looking west toward South Orange Avenue.

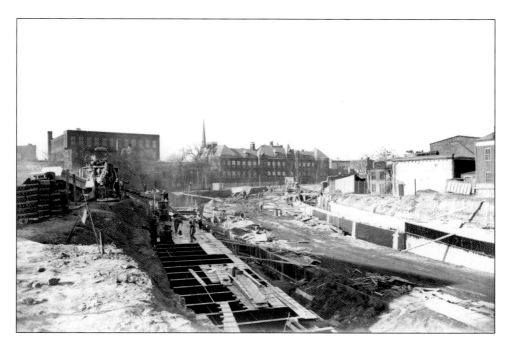

This would be the "roof" for the subway tunnel under Central Avenue. The curving road to the right would become the ramp for Central Avenue trolleys.

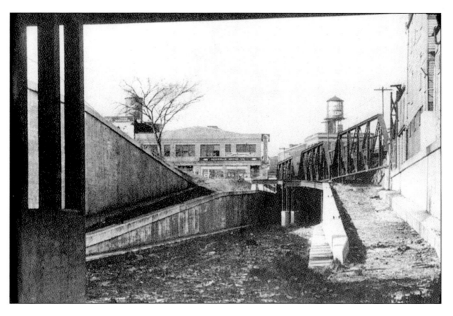

The tunnel for the subway began here as the roadbed dipped beneath the surface.

Goings and Comings

INEVITABLY, New Jersey was changing in a variety of ways: some history was lost and some was saved. Residents had, for example, almost forgotten the "Old Mine Road," in Warren and Sussex Counties, the oldest road in the nation. Older railroads had vanished, leaving their tracks behind them. Some old farms were falling under the auctioneer's gavel.

However, change was not all one way. Some of the past was being saved by such things as reinforcing the base of old Barnegat Light, to keep it from toppling into the sea. A future monument rose slowly on High Point—a towering obelisk to honor war veterans. And, ever so slowly, bulldozers began transforming some oceanfront land into building lots for cottage developments.

One set of Harry Dorer pictures caught an attempted revival of the past. By the 1930s the silver screen had become the major amusement industry in America. Movie making had begun at Thomas Edison's laboratory in America in West Orange and spread from there to several Bergen County locations. The famous "cliffhanger" series *The Perils of Pauline* was shot in Fort Lee. But filmmaking became California's domain after 1920. When moviemakers tried to bring the industry back to New Jersey in the 1930s, Harry shot the action. Unfortunately, this brief revival quickly faded into nothing.

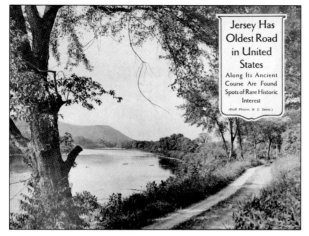

Jersey Has Oldest Road in United States

Along Its Ancient Course Are Found Spots of Rare Historic Interest

(Staff Photos, H. C. Dorer.)

The Old Mine Road paralleled the Delaware River in New Jersey, extending from Delaware Water Gap northeastward to Esopus (now Kingston), New York. It was built in the 1650s by Dutch prospectors to bring copper ore from a mine near the Gap to the port of Esopus for eventual transshipment to Holland.

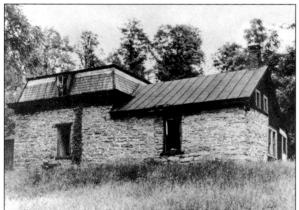

One of the buildings on the Old Mine Road was Fort Normanock, allegedly used as protection during Indian wars. It had been remodeled into a private home.

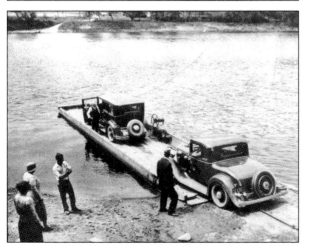

About thirty miles north of Delaware Water Gap, at Dingmans, travelers of the 1930s could cross the Delaware River on the Rosenkranz Ferry, an ingenious craft guided across the river by an overhead cable and the river current. A low-flying plane ran into and snapped the cable during World War II, closing the ferry forever.

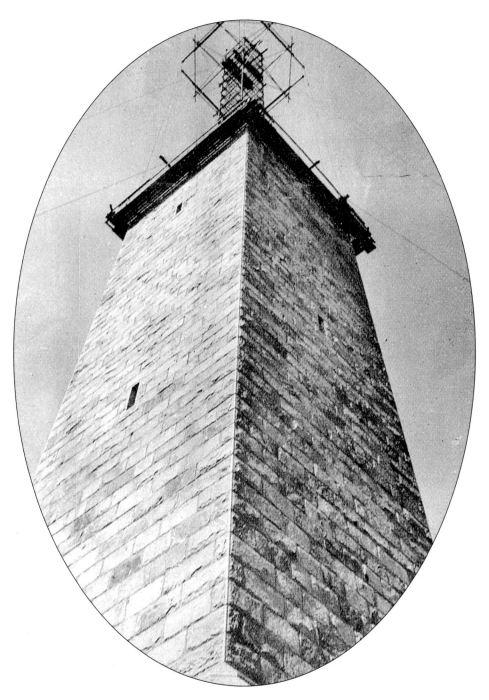

The top of New Jersey was to be marked by the 220-foot-tall High Point Monument, dedicated to veterans of World War I. Harry shot the monument in 1929 when it was about half finished.

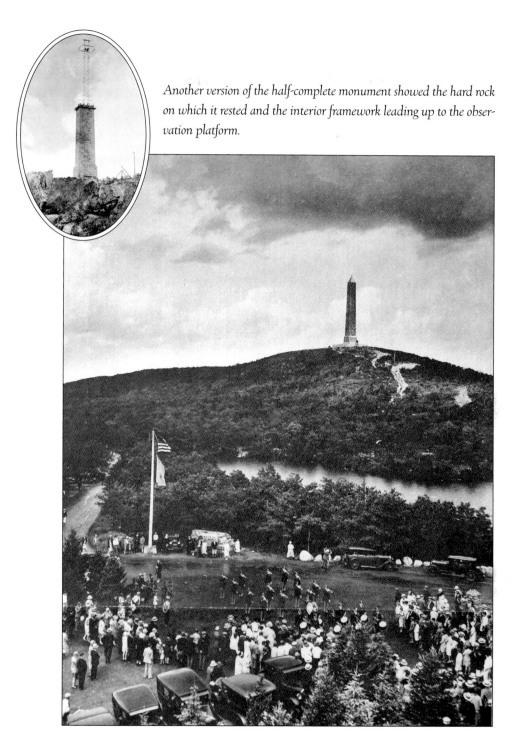

Another version of the half-complete monument showed the hard rock on which it rested and the interior framework leading up to the observation platform.

Harry was of course present when the High Point monument was finished. His photograph takes in part of the crowd at the monument's dedication.

Country auctions reached a peak during the Great Depression. This one is in Sussex County. Most people arrived in older cars, predominantly Fords.

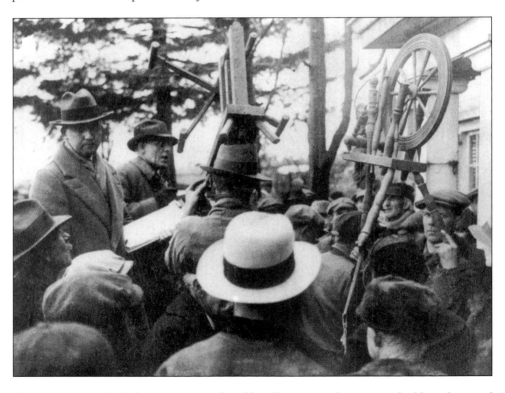

The auctioneer sought bids on rare items. This old, well-maintained spinning wheel brought a good price from one of the city dealers at the scene.

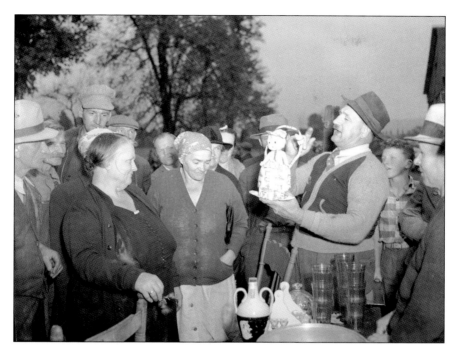

Another auction, with the auctioneer holding aloft what he believes will be of special inter-est to buyers.

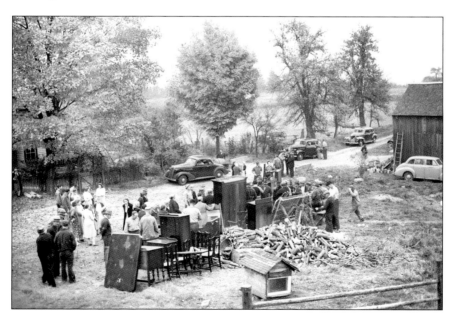

Everything offered for sale that day was piled neatly in a space set aside on the lawn.

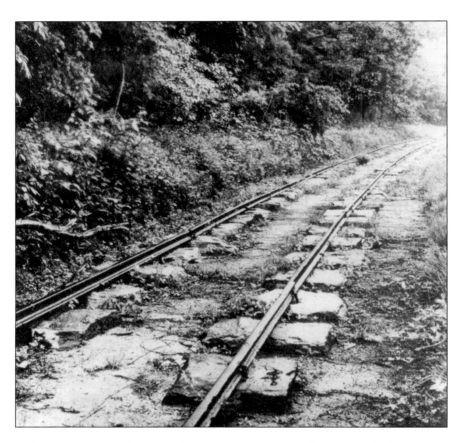

At Jamesburg, Harry photographed this section of track from the Camden & Amboy Railroad, New Jersey's first railroad. The tracks were on stone slabs, predecessors to the later wooden ties. This became one of Dorer's most reprinted pictures.

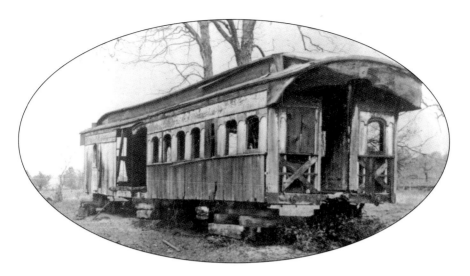

Harry found this old wooden passenger car, a relic from the Rockaway Valley Railroad, near Whitehouse. The road was launched in 1888 and died during World War I, when its rails were removed and sold for scrap. The picture marked a double ending: the last of dangerous wooden passenger cars and the demise of the Whitehouse-to-Morristown railroad.

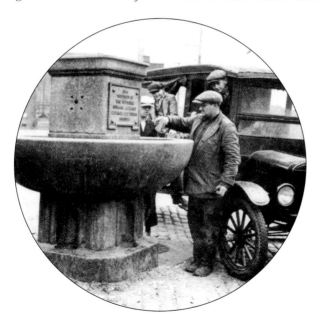

When Harry took this photo of a horse fountain in 1929, horses were vanishing from the streets of Newark and a motorist used the water to fill the radiator of his horseless carriage.

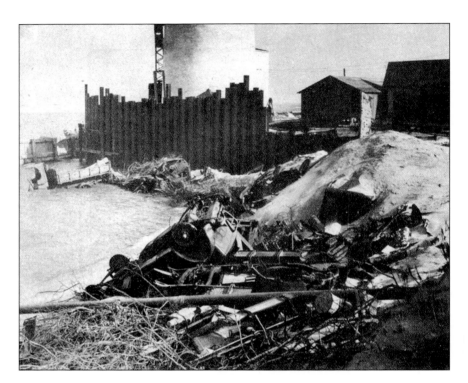

At the northern point of Long Beach Island, many motorists had donated (or dumped) old automobiles and other heavy metal objects to stabilize the base of Barnegat Light to keep the landmark from toppling into the sea.

FACING PAGE: *From a more distant vantage point, Harry showed the steel piling being sunk around the lighthouse, insuring a long life for "Old Barney," the foremost symbol of the Jersey Shore.*

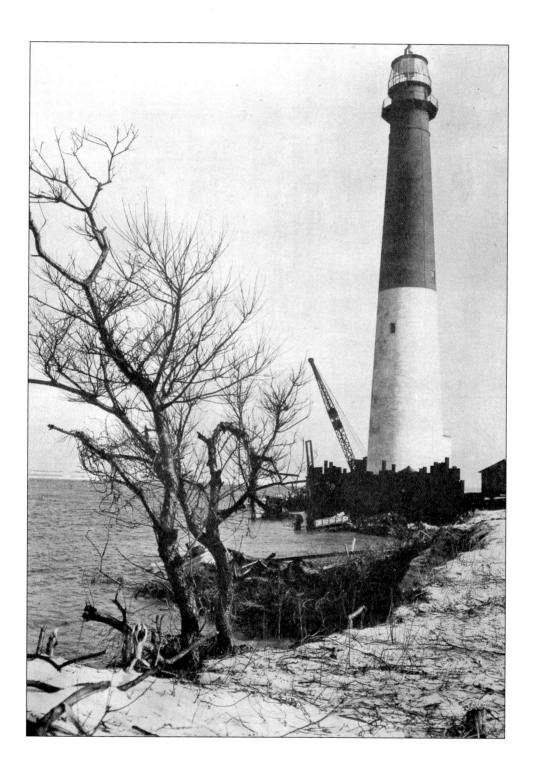

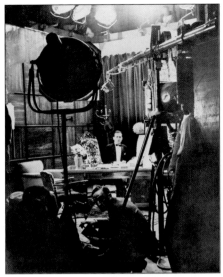

LEFT: *Production of the film* Enemies of the Law *at the RCA Sound Studio in North Bergen in 1931 provided hope that the thriving industry might return to its beginnings in Bergen County.*

BELOW: *Harold Godsoe, assistant director, director Lawrence Windom, and Frank Zucker, cameraman, shooting a scene.*

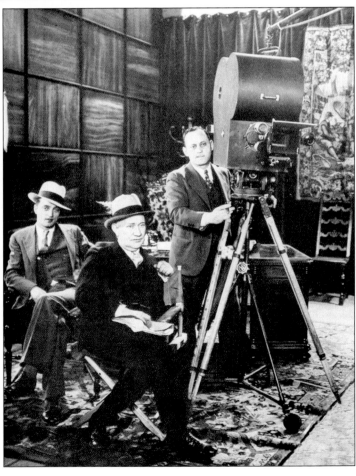

RIGHT: *Mary Nolan and Johnnie Walker,* *stars of* Enemies of the Law, *rehearsed a tense scene from the drama. The movie was made in the early years of the "talkies," as sound films were called.*

BELOW: *Definitely in the last stage of life were two Union veterans of the Civil War, over-looked by a portrait of Abraham Lincoln, at the New Jersey Home for the Disabled Soldiers in Kearny. The home was torn down in 1932.*

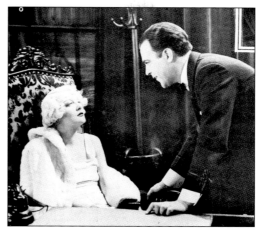

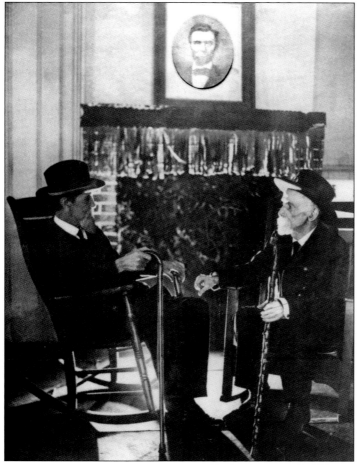

CHAPTER NINE

The Wild Blue Yonder

WHEN NEW JERSEY took to the air in earnest during the early 1920s, Harry Dorer climbed aboard. Travel through the air intrigued him, whether the mode was a modern airplane or a glider off on a journey of a few hundred feet. He photographed the beginning of airmail flights at Hadley Airfield in Piscataway and the rise in 1928 of Newark Airport from the marshy Newark Meadows. His camera captured the first passenger flights to California, the forerunner of transcontinental travel. A major interest was construction of a national dirigible complex in the sandy pinelands at Lakehurst. He and his camera were present and he was permitted to be aboard when some of the first lighter-than-air blimps soared at Lakehurst. He was on hand when the huge ocean-crossing German zeppelins arrived in the 1930s (although no photos of zeppelins appeared in his collection).

The U.S. Navy honored Harry by permitting him to be in the cockpit of one of the blimps at Lakehurst, the United States terminus for flights from Europe. Dirigible flights ended in May 1935 when the Hindenburg *exploded and burned at Lakehurst.*

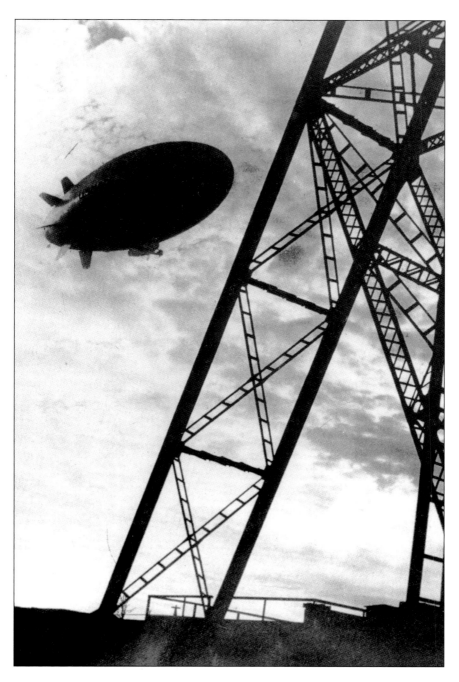

Harry occasionally flew in blimps stationed at Lakehurst. He was on the ground, however, when he made this artistic picture of a blimp etched against the cloudy sky and framed by braces on the Lakehurst hangar.

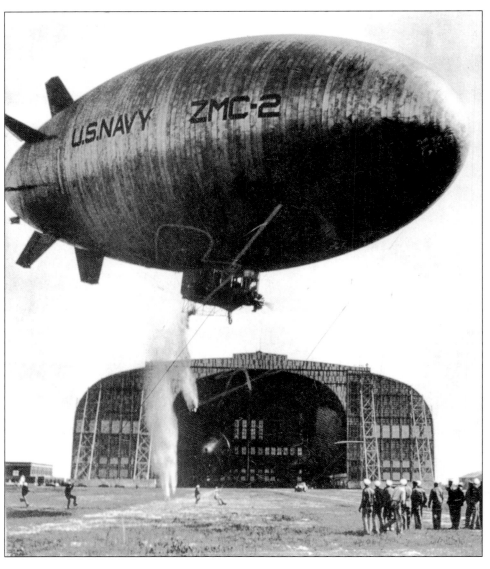

This navy blimp dropped sand ballast as it rose above the huge hanger.

FACING PAGE:

TOP: *Harry recorded the first airmail service between Hadley Field and Chicago in 1924. Metropolitan New York airmail planes originally took off from the Belmont Race Track on Long Island, but the dangers in flying over New York City made pilots wary.*

BOTTOM: *A Hadley Field pilot, with the familiar helmet and goggles of a 1920s airman, checked his flight orders. The airmail bags are casually heaped on the floor at his feet.*

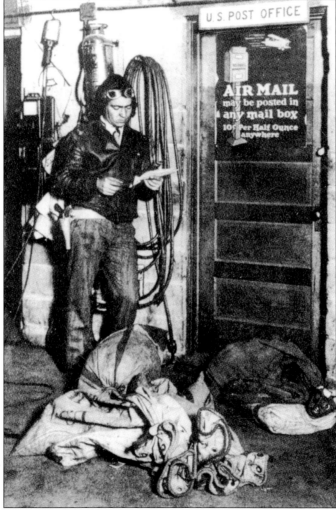

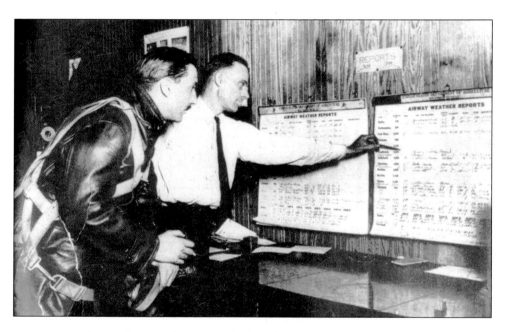

Before heading out, the pilot checked weather patterns on the flight's route.

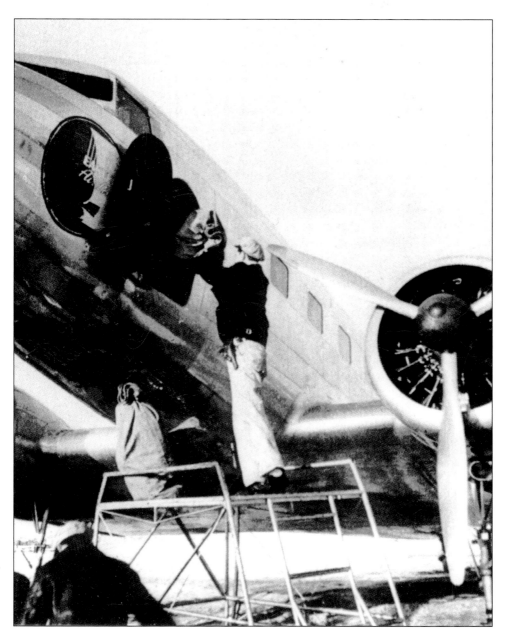

The mailbags were lifted aboard the plane just before takeoff. Note the pistol at the waist of the pilot.

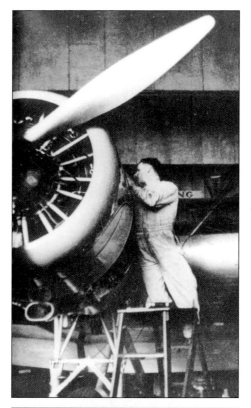

Harry took his fans on a rotogravure tour of the newly opened Newark Airport in 1929, first showing a mechanic working on an engine.

The tour was informal enough to permit two curious ladies to stand very close to the propeller.

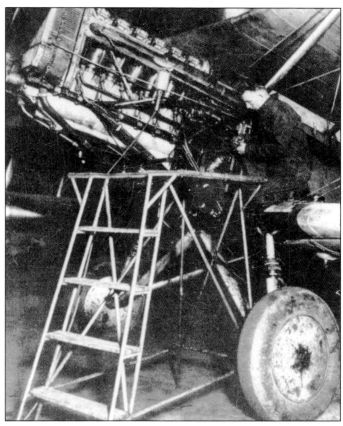

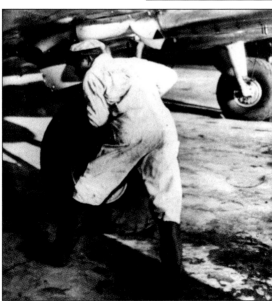

TOP: *Every engine underwent a complete periodic overhaul.*

BOTTOM: *Testing each tire was vital. A blowout on landing or takeoff could have serious consequences.*

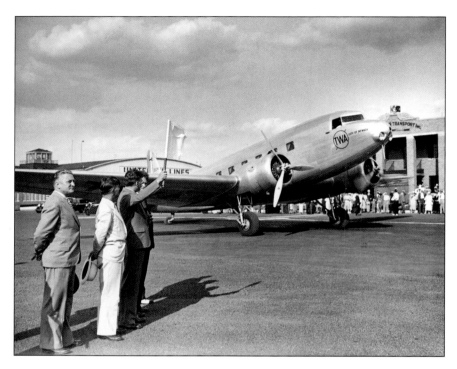

One of TWA's new planes being readied at Newark Airport for its maiden flight. Passengers left the terminal and walked out to board the plane.

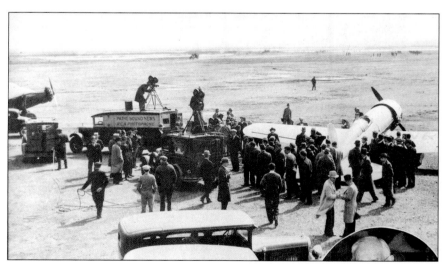

Reporters and movie news cameramen swarmed about the plane of Lou Reichers of Arlington, New Jersey, after a trial spin on May 10, 1932, prior to his plan to take off for Europe.

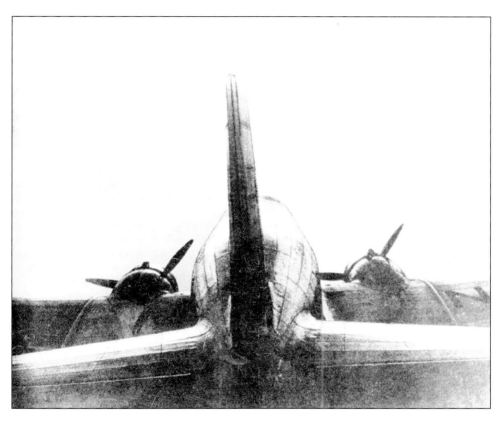

One of Harry's most acclaimed photos was this shot of a two-engine plane, taken on the ground but giving the appearance of soaring into the clouds ahead.

CHAPTER TEN

Down to the Sea in Ships

THE ATLANTIC OCEAN was a rich source of every kind of seafood, and New Jersey's role as a preeminent harvester of those riches was known wherever commercial fishermen went down to the sea in ships. They sailed most mornings from many New Jersey ports.

But New Jersey fishermen were not the only ones who reaped the Atlantic's harvest. In the 1920s, when mackerel were running strong off the Jersey Shore, the mighty mackerel fleet from Gloucester, Massachusetts, dropped anchor in Cape May. Their masts rose high above the port and the fleet was a sight to see as it set sail to seek schools of mackerel.

A favored New Jersey fishing technique was the "pound," as in *impound*. Fishermen rowed their boats offshore, dropped the wide-spreading pound nets in known fish haunts, and let the fish swim into the nets from which there was no escaping. The fishermen rowed out on regular schedules to take in the impounded fish, then rowed back, beaching their boats high on seaside strands.

A major part of the shellfish industry was New Jersey's oyster fleet, with its home base on the Maurice River in Cumberland County. Whenever oysters were in season (any month containing an *r*), the oyster fleet set out before dawn to the oyster beds in the Delaware River, a few miles north from where the Maurice River entered the Delaware.

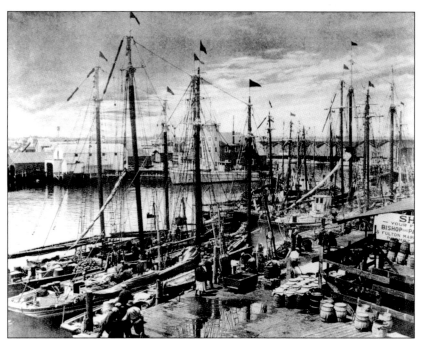

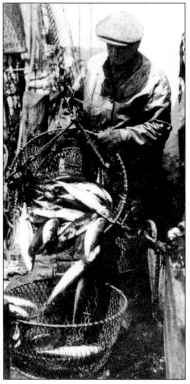

TOP: *The visiting Gloucester fishermen's vessels crowded the Cape May docks. At least fifteen tall New England masts appear in this picture.*

BOTTOM: *The long, sleek mackerel were transferred to metal mesh baskets for lifting down to the dock.*

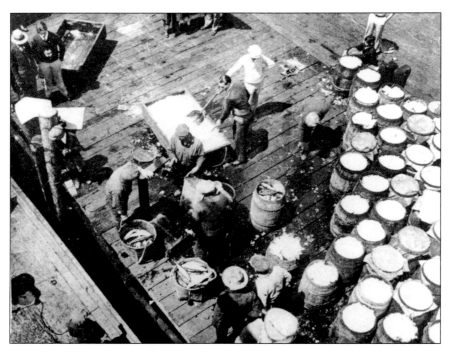

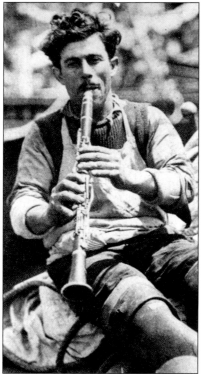

TOP: *At day's end, scores of barrels of iced mackerel were on the dock, ready for shipment along most of the North Atlantic coast—even as far as Gloucester.*

BOTTOM: *When the packing was finished, a Gloucester fisherman relaxed to the sound of his clarinet.*

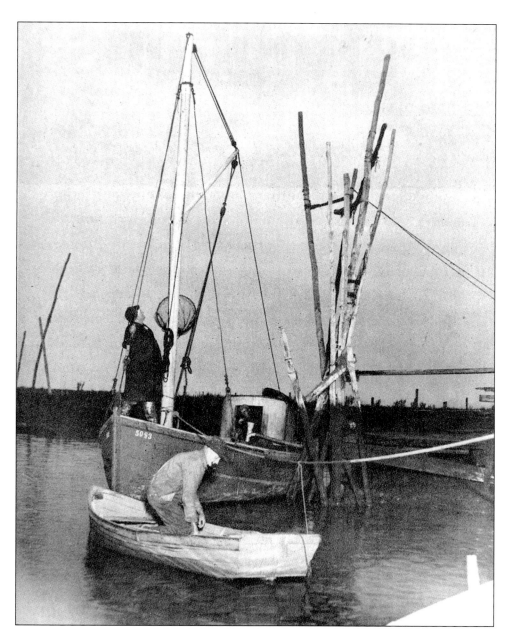

Pound fishermen staked out a territory in the ocean, then spread a net that directed fish into an enclosed section from which there was no escape.

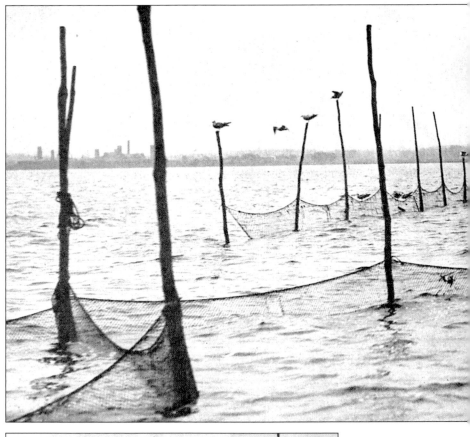

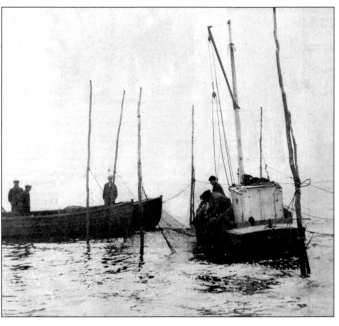

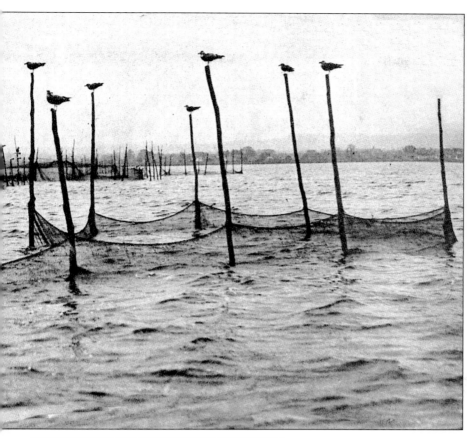

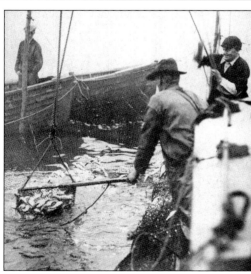

ABOVE: *Long poles sunk into the ocean floor held the pound net in place.*

FACING PAGE, BOTTOM: *The net was fastened in place and the fishermen returned to shore.*

LEFT: *On their return, fishermen found the net filled with varieties of fish that later would be sorted out by species before being marketed.*

When his share was dumped into his boat, this fisherman stood knee-deep in his catch.

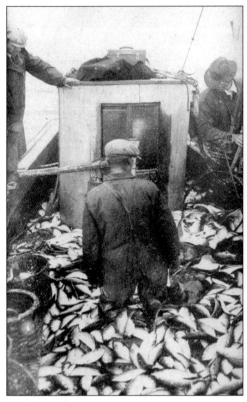

Oyster boats tied up at Mauricetown on the Maurice River, blending into a complicated pattern of masts and hulls.

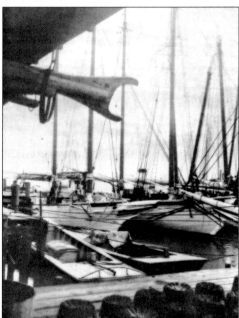

FACING PAGE: *With his sails only partially set, an oyster boat skipper entered Delaware Bay.*

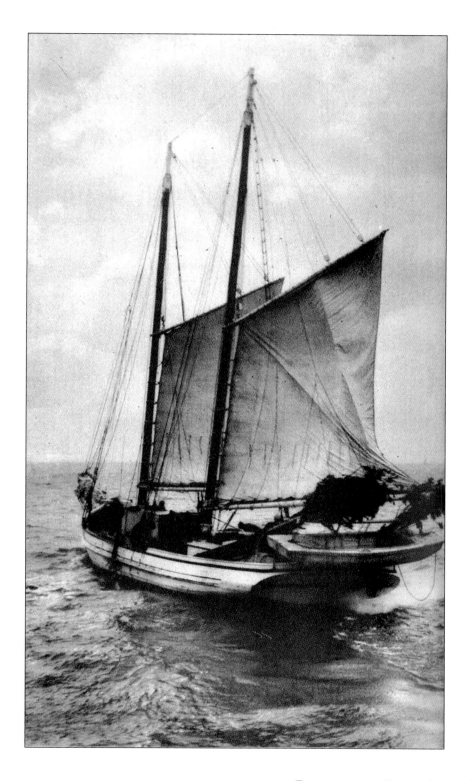

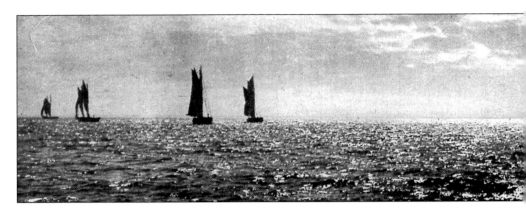

The oyster fleet, setting out at sunrise, was ample reason for Harry Dorer to snap a photo of the boats spread across the horizon.

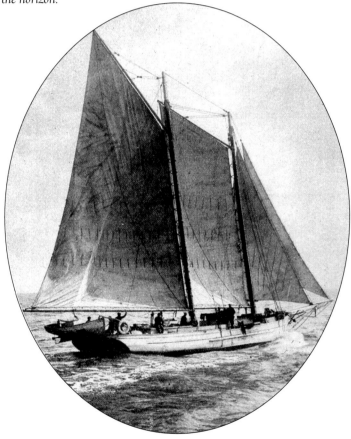

An oyster boat with all its sails filled with wind made a compelling sight on the open bay.

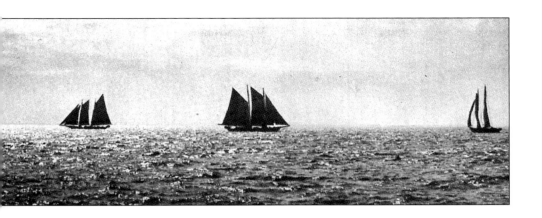

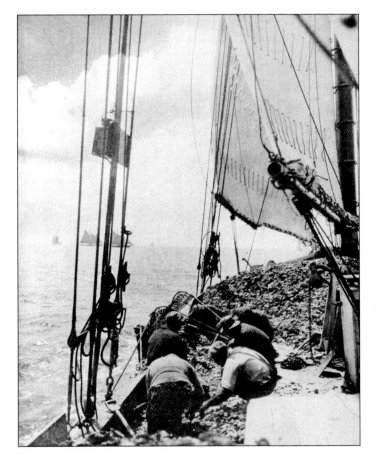

When day was done, boats pulled into Bivalve on the Maurice River with foredecks piled with coveted oysters.

Contrasts in the Great Depression

THE GREAT DEPRESSION struck New Jersey savagely after the New York Stock Exchange collapsed in October 1929. Banks failed, most of heavy industry closed its doors, hundreds of thousands were jobless and penniless, and many men took to living in makeshift shantytowns. Some of the unemployed sold fruit on city street corners. "Brother, Can You Spare a Dime?" became the nation's widespread (and saddest) anthem.

The Depression hit urban areas hardest. Many farmers had lived for years with little cash after bills were paid. They merely went from being poor to being very poor. In 1929, the average factory worker's wage was $839 a year. By 1935, that had dropped to $433.

Government agencies helped the unemployed, although wages were low. Civilian Conservation Corps (CCC) workers received $21 a month (70 cents a day) for the work they did improving parks and other public facilities. WPA workers started at $35 a month ($420 a year).

Those with heavy investments in the stock markets sustained huge losses, but not all rich people suffered. A select few maintained their yachts and palatial homes, enjoyed country club memberships, posed for pictures at charity balls, and rode horses in pursuit of foxes in the Somerset County hills.

FACING PAGE: *If any brother could spare a dime, he received four tangerines or two oranges from this vendor who stood in a snowstorm in Orange, offering his wares at a makeshift fruit stand.*

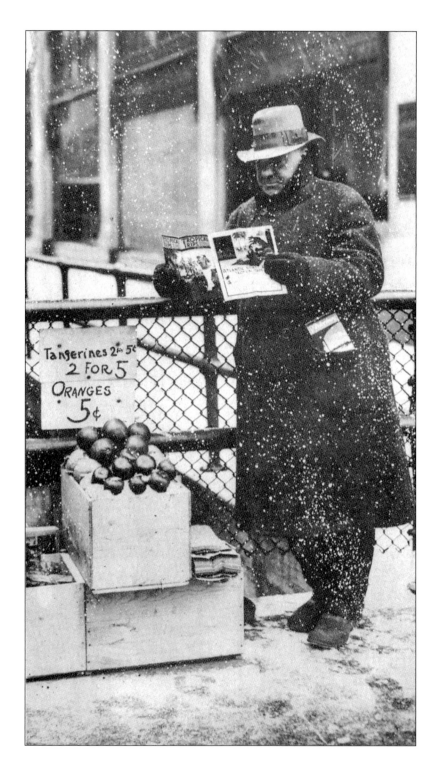

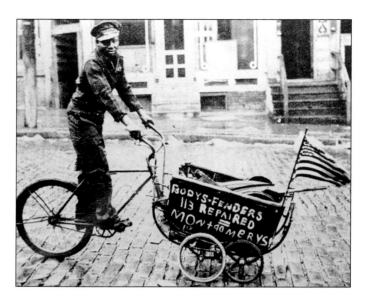

An entrepreneur (presumably named Montgomery) brought his equipment for repairing of fenders and auto "bodys" to customers via this homemade traveling bicycle/baby carriage contrivance.

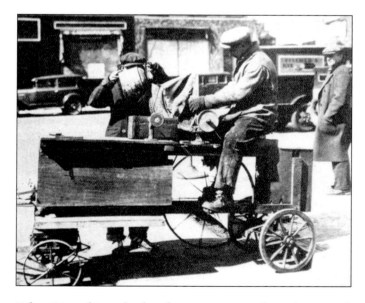

When Wynard Berry lost his job as an expert grinder with a Newark company, he built a traveling wagon with built-in grinder and earned a good living sharpening knives for butchers and other shopkeepers in the suburbs of Newark.

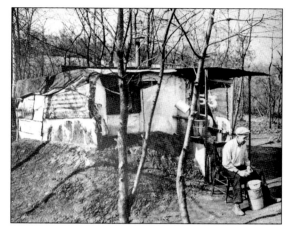

Many homeless and jobless men (known generally as hoboes) retreated to so-called jungles in the Newark Meadows or along stream banks close to Elizabeth or Newark. This camp, "Travelers Rest," beside the Elizabeth River in Union, was the province of "Steamboat Bill," a one-time California gold miner.

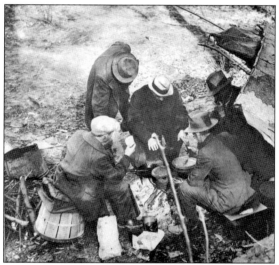

"Frenchy," a former chef (seated on peach basket), and "Typewriter George," an ex-newspaperman (seated right), called their shack in Union Township "The White House."

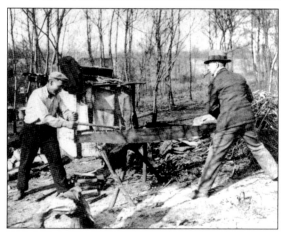

"Frenchy" (on left) and "Typewriter George" demonstrated a new skill as they cut a winter's supply of fuel from felled trees in their hobo jungle.

Congressman Robert Winthrop Kean and Mrs. Kean (flanked by two cigarette girls) hosted a social event at their Livingston estate in 1929.

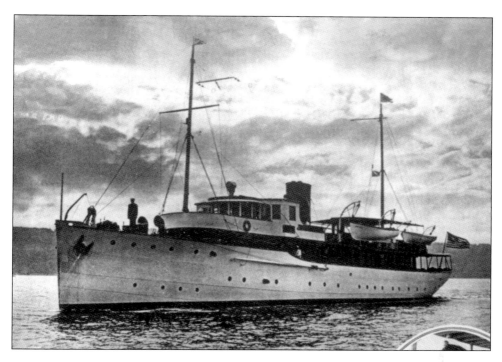

When wealthy banker Uzal McCarter, president of Newark's Fidelity Union Trust Company, needed rest and relaxation, he found it aboard his yacht Josephine.

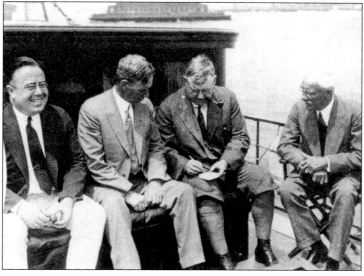

High-ranking executives or political leaders who needed to discuss matters in privacy were welcomed aboard McCarter's yacht.

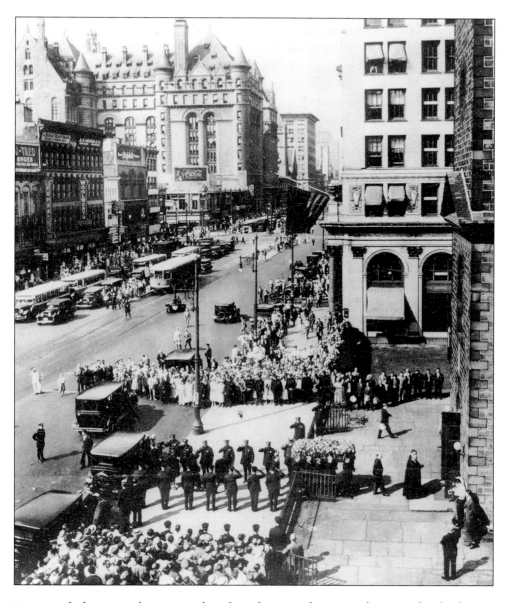

McCarter died in 1931 and was given a huge funeral in Newark's First Presbyterian Church. The Prudential Building, where he had his office, looms in the background.

FACING PAGE: *This picture, taken by Harry Dorer shortly before the tycoon's death, showed the banker applauding a drive at the company's annual golf outing.*

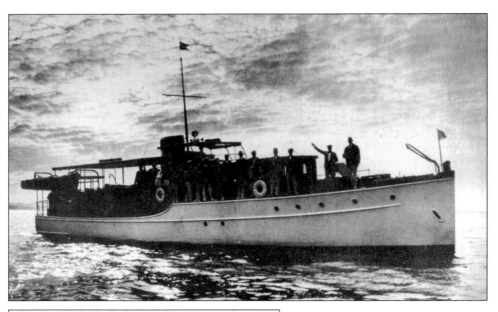

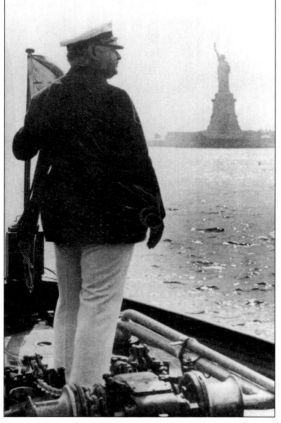

Another Newark yachtsman was Louis V. Aronson, holder of hundreds of patents, most notably for his well-known Ronson lighter. Aronson's yacht carried his coded initials: *Ellveeay*.

Aronson posed in the bow of his yacht as the vessel moved slowly past the Statue of Liberty.

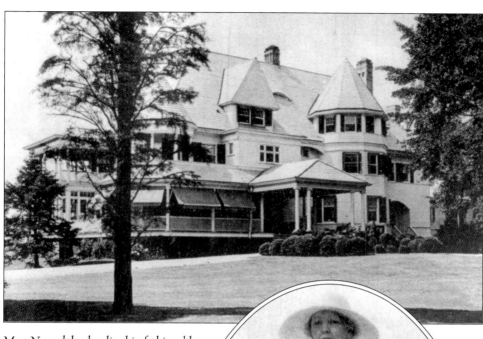

Most Newark leaders lived in fashionable enclaves well out of the city or left their Newark homes during hot summer months. This was the summer residence in Rumson of Christian Feigenspan, a noted Newark brewer.

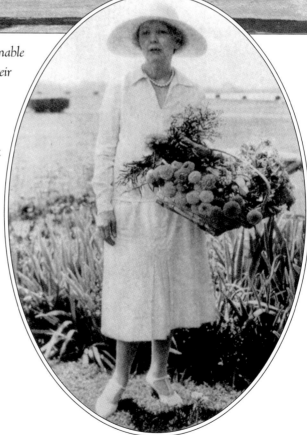

Mrs. Feigenspan posed in the garden of their summer home, aptly named "Meadow Grove."

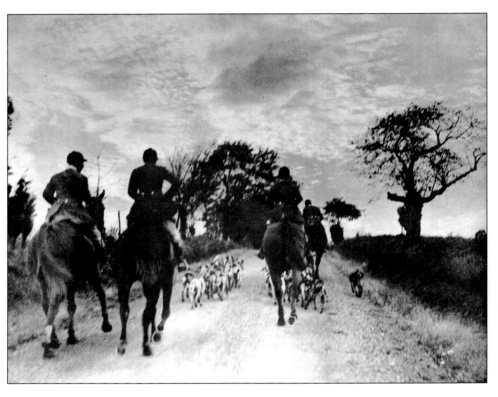

The Somerset Hills, from Bernardsville to Far Hills, had become a favorite address for many million-aires. One of the most cherished traditions was the weekend fox hunts behind barking hounds. Here the hunters and their hounds head out into the rising sun along a Far Hills country road.

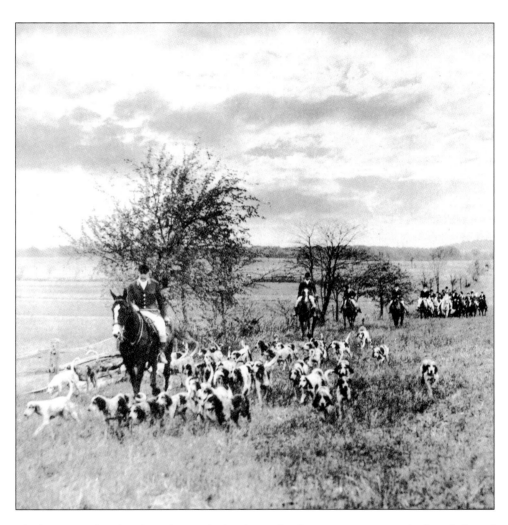

The hunters, gathered to the right rear, had to be on the alert. At any minute a barking foxhound would be on the scent of a fox.

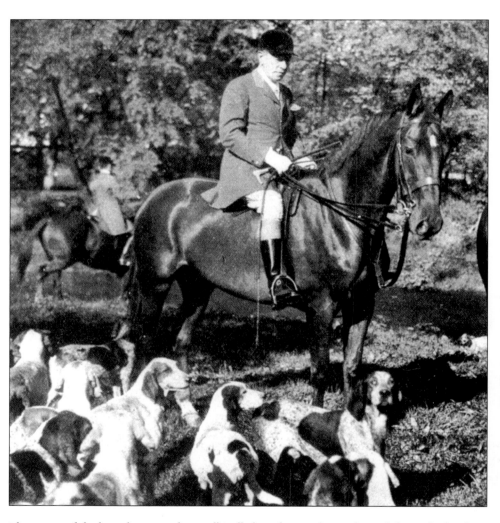

The master of the hounds was ready to call "tally-ho," the time-honored signal that a fox has been sighted. His signal set the hounds baying in pursuit.

Two purebred foxhounds, temporarily out of the hunt, posed meekly beside the daughter of one of the hunters.

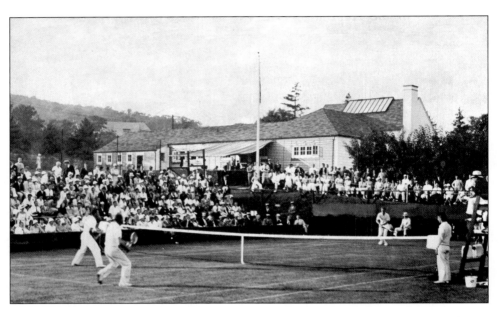

A place for complete spectator relaxation was the posh Orange Lawn Tennis Club, the scene of many national tournaments.

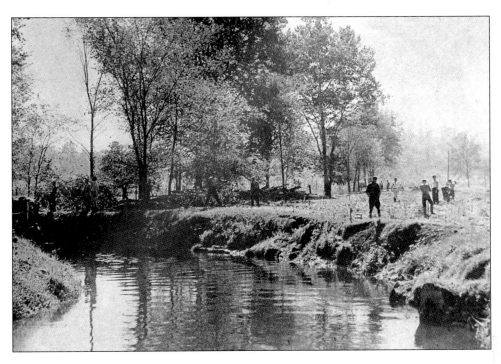

While some idlers needed to seek physical exercise, these very young CCC men would have all the exertion they could manage. This project would create a new course for the twisting Pequest River in Sussex County along the path where CCC men are standing.

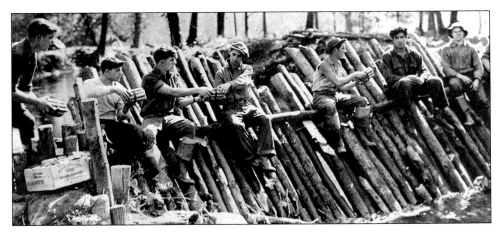

The task began on a production line, where dynamite sticks were taped together in bundles of ten.

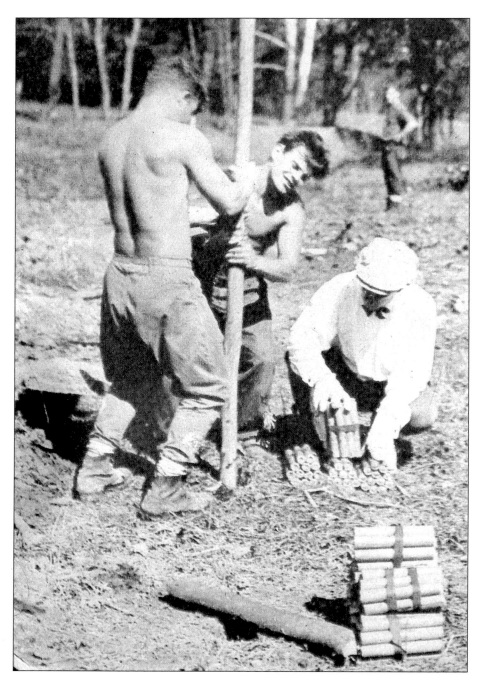

Two well-muscled men create one of the holes along the projected path, where the CCC men will place the dynamite.

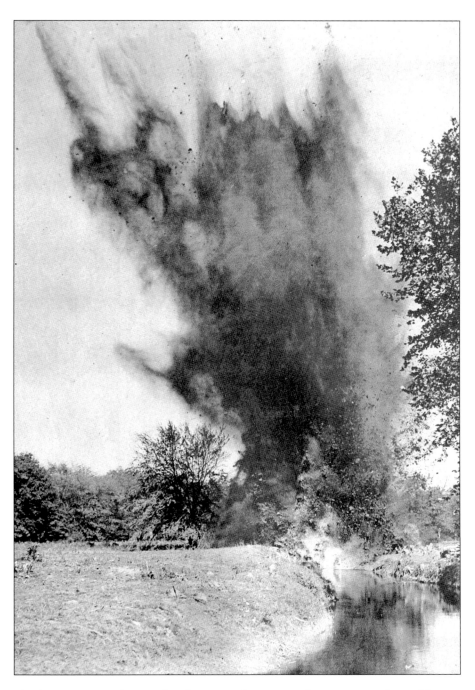

The dynamite erupted in timed explosions. Within minutes the Pequest was diverted from its historic bed, flowing in a path less prone to the annual floods that plagued the area.

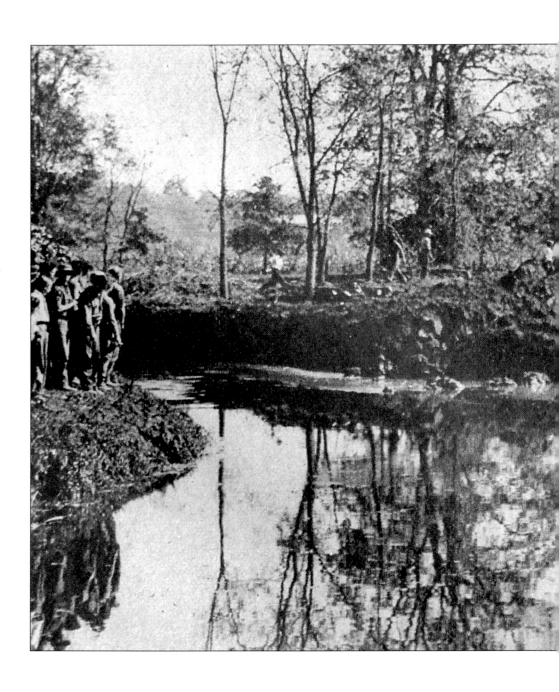

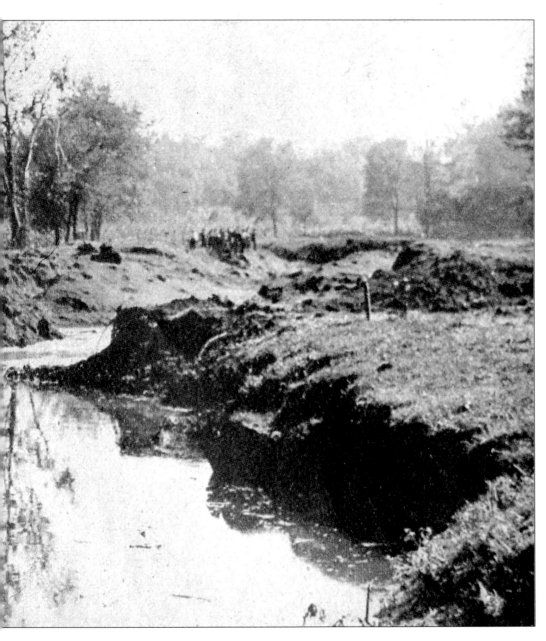

The course of the Pequest was changed forever. The young men achieved the feat at a bargain rate: seventy cents a day per man—plus uniforms (World War I vintage), food, and a barracks bunk.

CONTRASTS IN THE GREAT DEPRESSION | 123

Earning Their Livings

HARRY DORER often veered away from his first love—rural New Jersey—
to photograph industrial workers earning a living in unusual ways.
Some ventured across steel beams to erect skyscrapers in the cities and
lofty bridges across rivers. Others built country roads and city streets with their
muscles and simple tools. An important few went underground to extract iron
ore from the mines or blew glassware in southern New Jersey factories. To add
a touch of the unusual, Harry also visited a Passaic County farm where the own-
ers worked hard in season to produce and sell maple sugar products.

New Jersey's mountains had been yielding great quantities of iron ore for
nearly 250 years, usually with little attention. Harry brought the industry into the
homes of *Sunday Call* readers with a detailed pictorial depiction of the mines at

Ringwood in upper Passaic County.
The mining sequence was notewor-
thy as one of the rare depictions of
ironworkers gathering each day to
commit themselves to long, hard
hours deep under the ground. The
work was arduous, the pay was at
best ordinary, and the dangers obvi-
ous. As World War II grew ever
more ominously near, work in the
iron mines intensified to meet
demands both abroad and in the
United States.

*Muscular laborers used heavy tools to begin
work on repaving a street.*

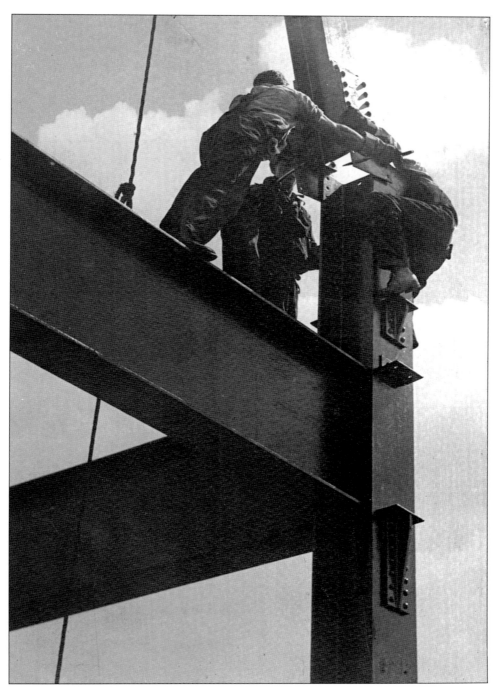

A special breed of men who could lay aside a fear of heights and with a willingness to dare worked on steel beams high above Newark's pavements.

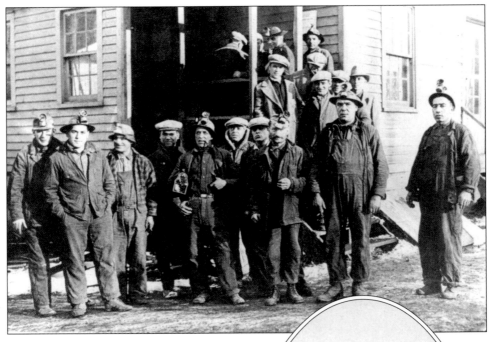

In Ringwood, men gathered early for their daily ventures into the deep mine, following longstanding family traditions of digging iron ore.

A miner checked the lamp attached to his helmet, vital in a pit of darkness.

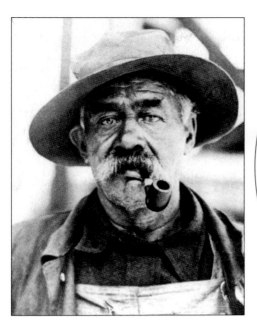

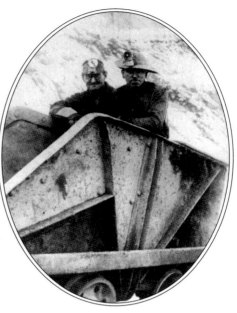

They were a rugged lot. Harry asked this man his name. He replied, "Oh, just Jimmy."

Their transportation to the end of the shaft was called a "skip." Two men traveled together.

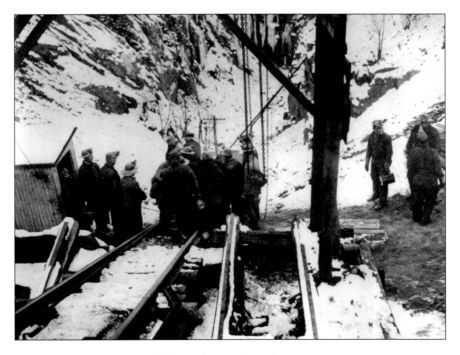

Miners rode down these tracks to the mine opening.

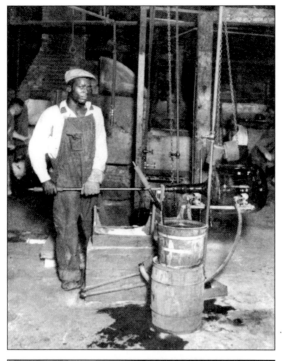

At the far southern end of the state, Harry found glassmakers. This man is "gathering" a hot mixture of molten sand.

Carboys cooling before shipment. Thousands of them were blown each day in one Salem factory.

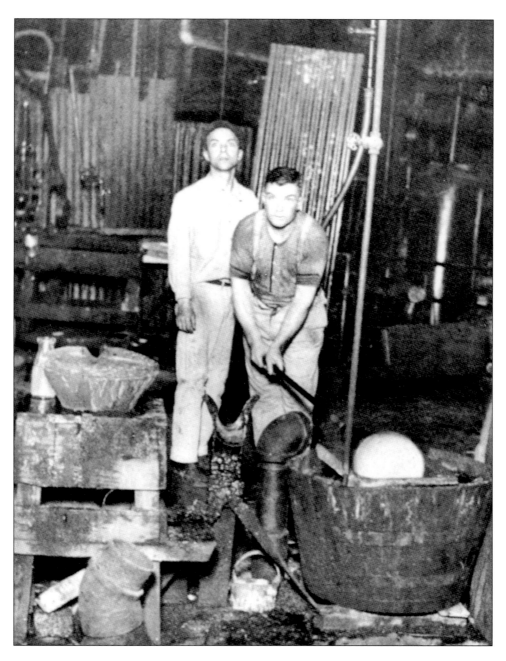

The molten mix was twirled until just the right size. The blower picked up the huge gob of glass to blow a carboy—one of the heavy glass containers used on an office water cooler.

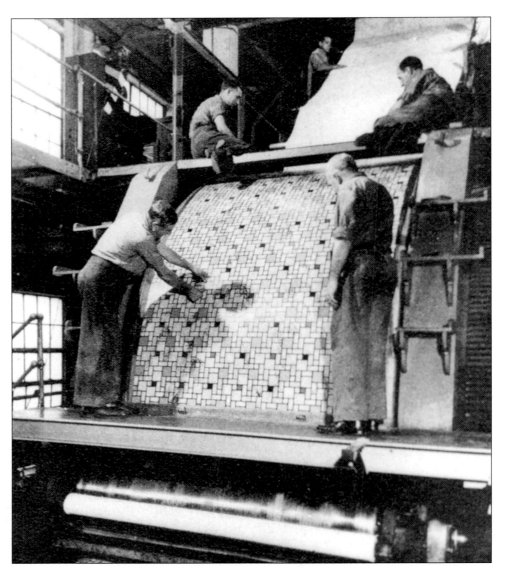

As a demonstration of industrial diversity, workers at the Congoleum-Nairn plant in Kearny watched floor-covering roll by, yard after speedy yard.

FACING PAGE: *Behind the products made in New Jersey's thousands of factories were researchers, seeking to improve their company's products. The state by 1940 had become a leading center for research facilities.*

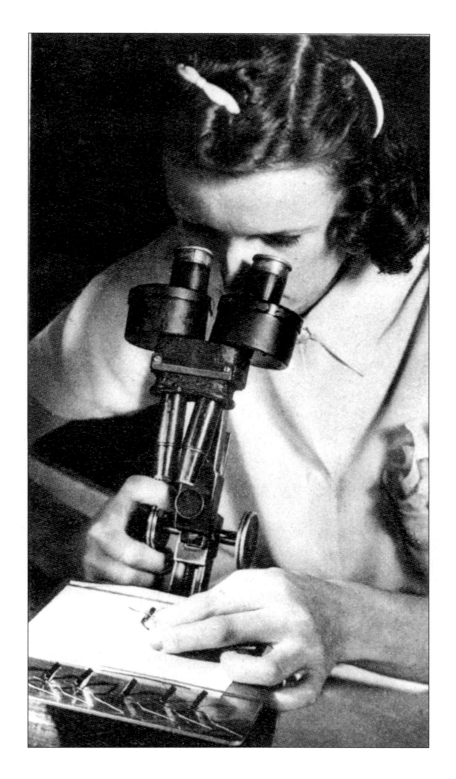

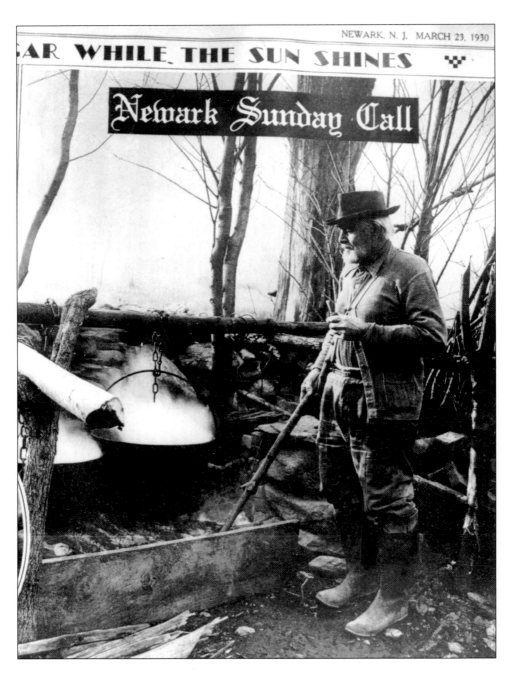

NEWARK, N. J. MARCH 23, 1930

AR WHILE THE SUN SHINES

Newark Sunday Call

The Post family had been making maple sugar products in northern Passaic County for a century. The process began with Charles Post removing sap from a maple tree and boiling it in large iron pots.

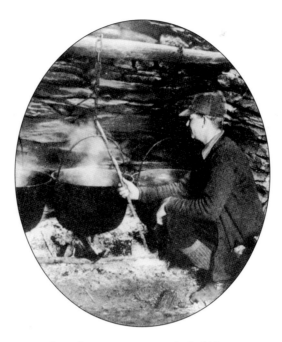

Fred Post kept a wary eye on the bubbling sap.
Thirty-six gallons of sap boiled down to a gallon of syrup, which sold for $6.50.

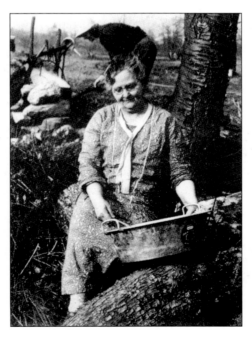

As the process neared its end, Mrs. Charles Post beat the syrup into maple sugar.

New Jerseyans at Ease

LEISURE TIME came abundantly—if unwanted—to hundreds of thousands of New Jerseyans who were out of work during the Great Depression. Increasingly they turned to the outdoors—to fish, to hunt, to play baseball, and to enjoy the frozen surfaces of lakes and ponds. They sought options that required spending time rather than money.

Nearly everyone could afford small ticket fees to watch the trotting races at Weequahic Park in Newark or at the annual State Fair in Trenton. There was no legal betting at these venues, although money was known to change hands freely on the outcomes of the races.

Harry Dorer photographed the trotters but he was in more his element when he rose at dawn on the first day of trout fishing season each April 1 to be with the throngs frequenting the swiftly flowing rivers in western New Jersey.

And, of course, he paid attention to the great American game—baseball, ranging from so-called "sandlot" leagues, where boys and young men played, to the professional Newark Bears—New Jersey favorites.

In summertime, he often visited one of the many camps on the myriad of small lakes in northern New Jersey. On the way home, he might stop at an old-fashioned farm pond swimming hole to get pictures of youngsters enjoying themselves without any of the trappings of camps or posh swimming clubs.

Some of his best pictures were taken on crisp winter days when he traveled to Lake Hopatcong or Budd Lake to watch iceboat skippers race across the ice or to record other kinds of vehicles that carried people swiftly through the winter air.

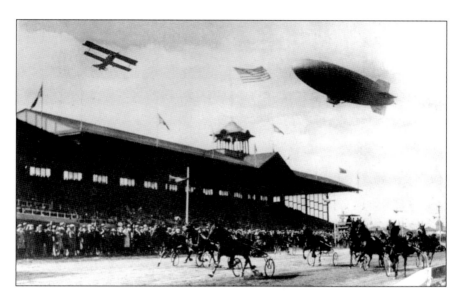

This Governor's Day shot at a New Jersey State Fair trotting race seemed surreal. The navy blimp floating serenely above the track and the airplane buzzing in from the left added dimensions that thrilled race goers. The fairgrounds are now the site of Grounds for Sculpture in Hamilton.

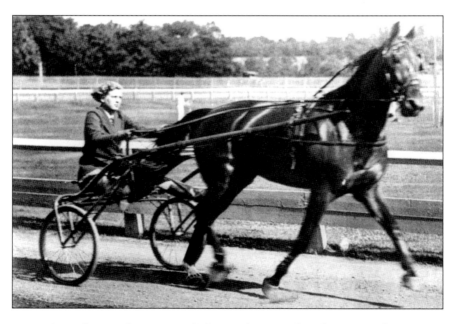

Weequahic Park racing fans were much closer to the action than they were at the State Fair races. They cheered this skilled female driver as she guided her horse to victory.

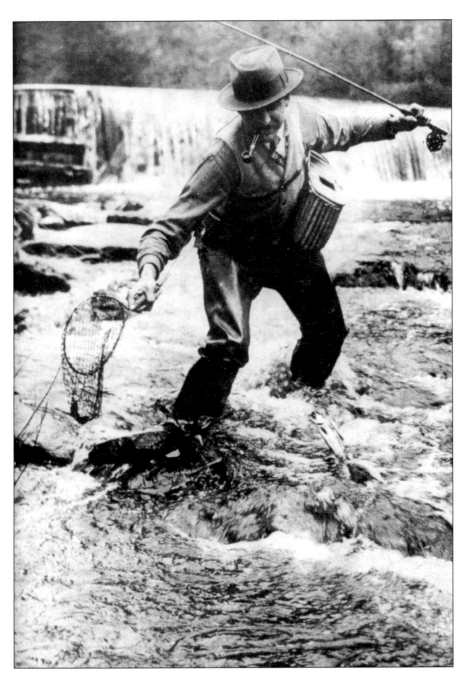

But genuine lovers of the outdoors were equally thrilled by Harry's dramatic shot of a fisherman about to net a trout in the swiftly moving Musconetcong River below Saxton Falls in Warren County, one of the state's best trout-fishing spots.

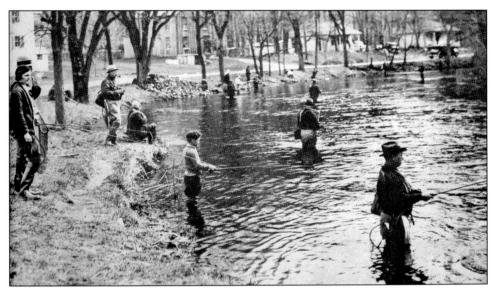

More serene than Saxton Falls but equally cherished was this cold river in Hunterdon County, probably one of the upper branches of the Raritan River. A little boy and a woman added variety to the high-booted fisherman fishing in deeper water.

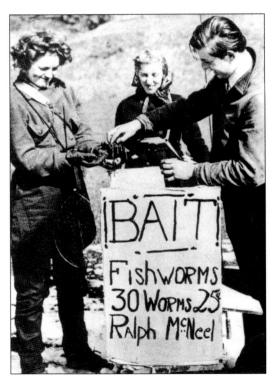

This apparently neophyte angler didn't seem to be thrilled with handling fishing worms, even at the bargain rate of thirty worms for twenty-five cents.

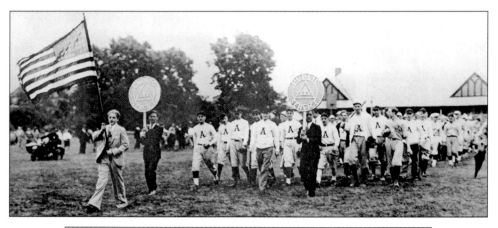

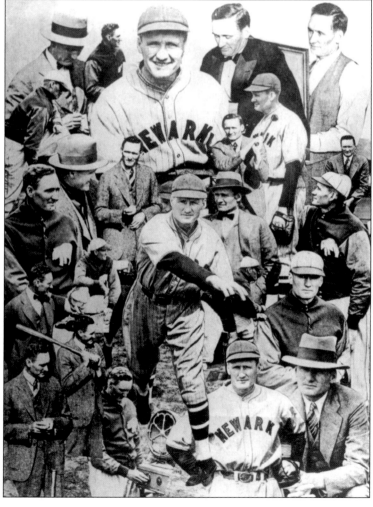

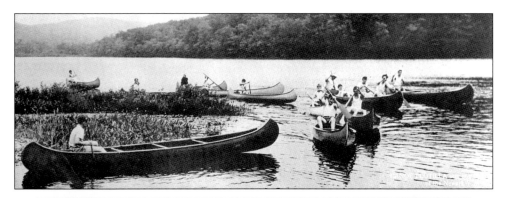

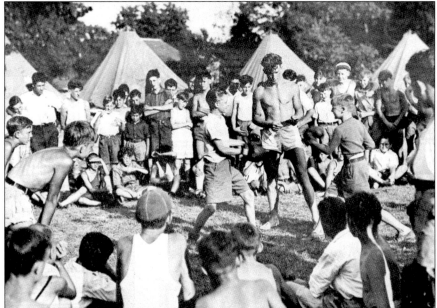

TOP: *Summertime brought outdoor fun to thousands of boys in New Jersey's numerous camps. Canoeing on the camp lake was always a highlight.*

BOTTOM: *A counselor, likely a college student working at camp for the summer, supervised a friendly boxing match.*

FACING PAGE:

TOP: *Spring also meant baseball. Many thousands of New Jersey's young men and boys played ball without the benefit of Little League or other adult-run leagues. Opening day for juniors in Newark included a parade for teams representing many age groups.*

BOTTOM: *Harry created this montage of the Newark Bears to include as many fan favorites as possible.*

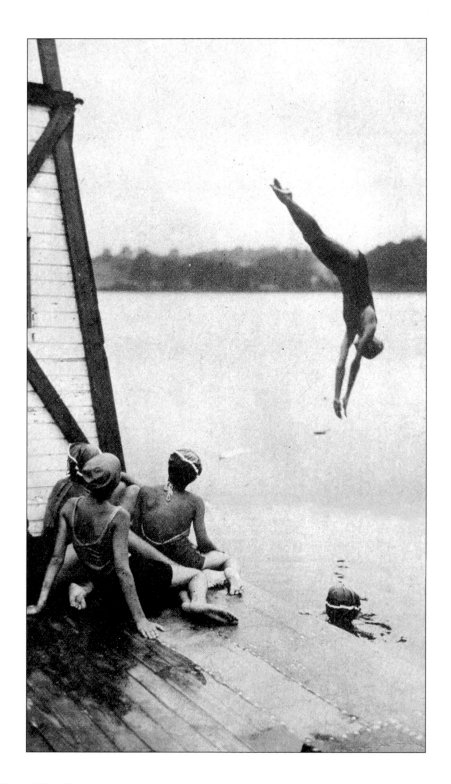

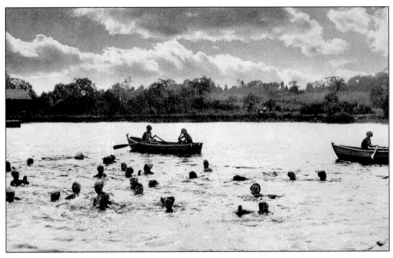

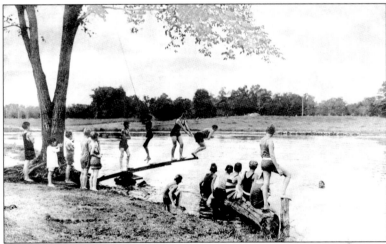

TOP: *Water time for younger swimmers called for careful attention by the counselors to insure safety was not neglected.*

BOTTOM: *Swimming was not confined to camps. The water was fine at hundreds of swimming holes or farm ponds. This was a summer scene at Noe's Pond in Chatham.*

FACING PAGE: *A nearly flawless diver completed her jackknife at exactly the right time to make Harry's shot a thing of beauty.*

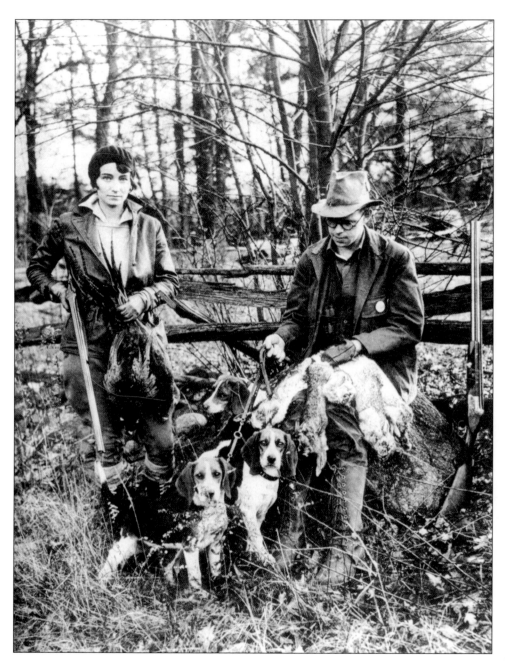

With almost unlimited farm fields and woodlands available throughout the state in November, a very popular sport was hunting for rabbits and pheasants.

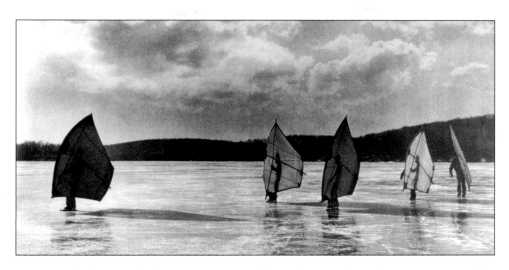

Winter made skating and other winter sports popular nearly everywhere. This variation on ice-skating allowed skaters to use a sail to propel themselves at high speeds.

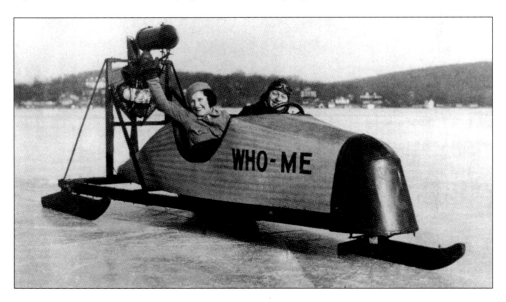

Skates were far from the only way to enjoy the ice, as proved by this power-driven, two-person craft.

Off the Beaten Track

Harry Dorer's most startling photographs were his documentation of a major Ku Klux Klan presence in New Jersey. Usually associated with the Deep South, the Klan had enough power in the state to convince a Newark minister to lend his church's support and pulpit to a Klansman, disguised in his hooded costume, to profess the Klan's bigotry and racial and religious hatreds. These photos, all taken in 1922, were important: at that time the Klan had a membership of 60,000 in New Jersey and was represented in all twenty-one counties.

In another bizarre story with a strong undercurrent of evil, Harry photographed the Ward Line's luxury cruiser, the *Morro Castle,* after her smoking hulk went aground close to the Asbury Park Convention Center on September 8, 1934. The captain and crew acted scandalously the previous day when the ship caught fire as she was returning to New York City. Abandoning ship in lifeboats with little regard for passengers, those who fled left behind 137 dead or dying passengers and crew members. The ship itself became a temporary tourist attraction for several days.

FACING PAGE:

TOP: *Four hooded Klansmen, reminders of southern lynchings and wanton cruelty, made a grim statement as the men rode in 1922 through the darkness on a central New Jersey country road near Point Pleasant. Even the horses were hooded.*

BOTTOM: *Four hooded leaders, possibly the horsemen in the first photo, rose at a Klan rally to preach their gospel of multiple hatreds.*

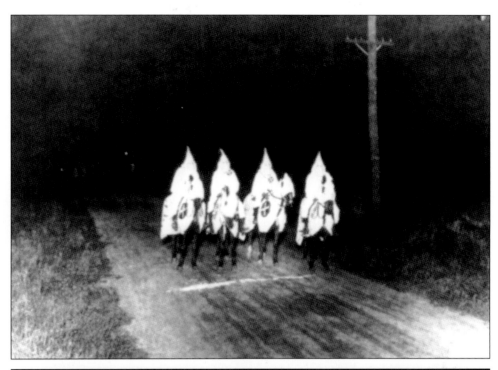

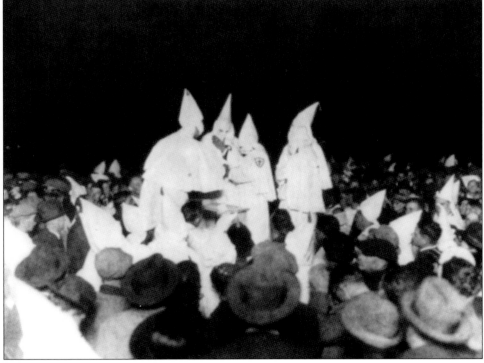

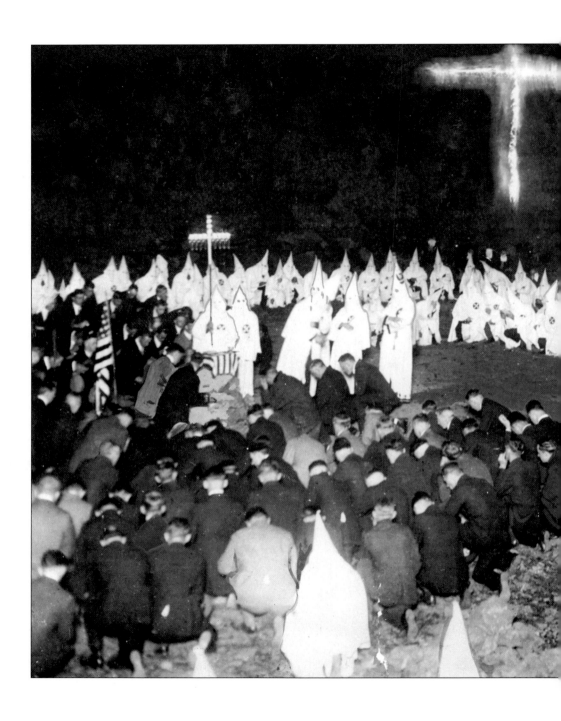

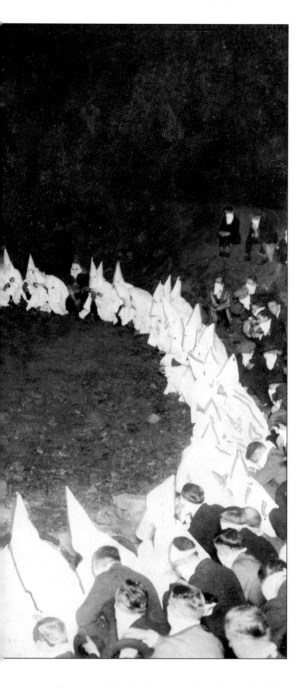

Klansmen rallied in large numbers beneath a flaming cross in a "mystic circle" installation at a Murray Hill quarry in Union County. The young men with bowed heads swore allegiance as "100 Percent Americans."

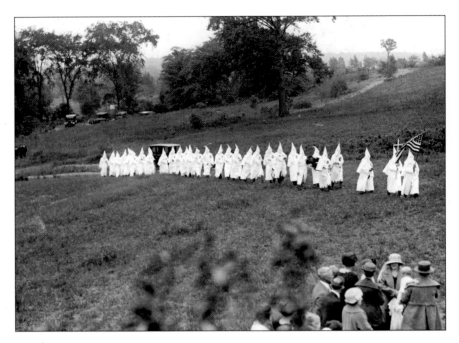

Although Klansmen preferred the darkness of night, these hooded men rallied in daylight at the Delawanna Cemetery in Bergen County's Carlstadt.

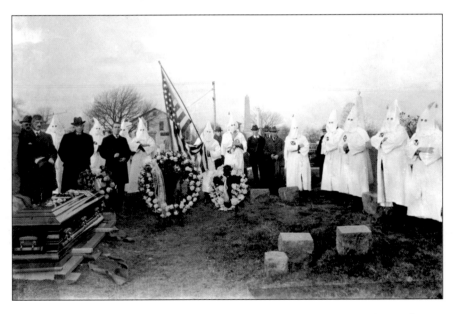

The Klansmen had come to Carlstadt under the American flag to lay wreaths in tribute to one of their deceased members.

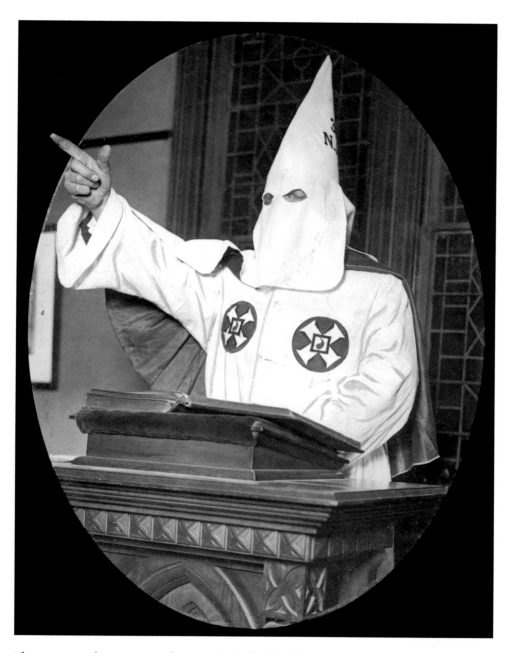

The minister and congregation of a Newark church offered their pulpit to the "Exalted Cyclops" in a major service.

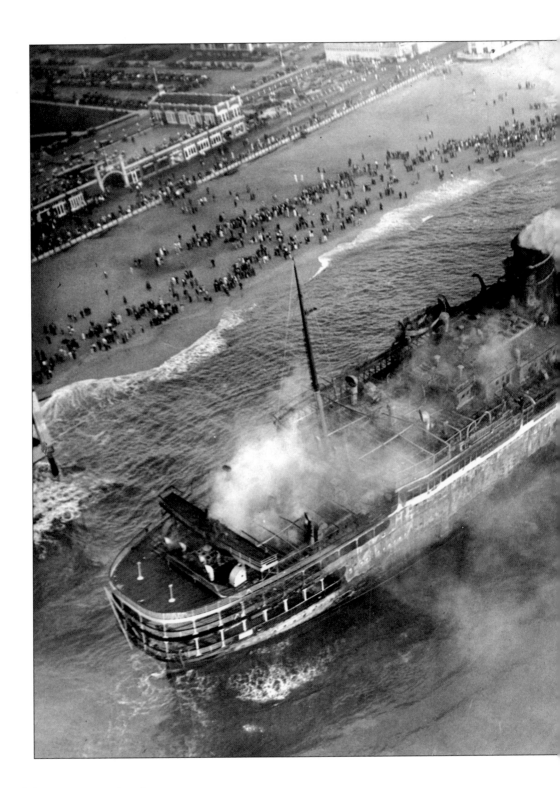

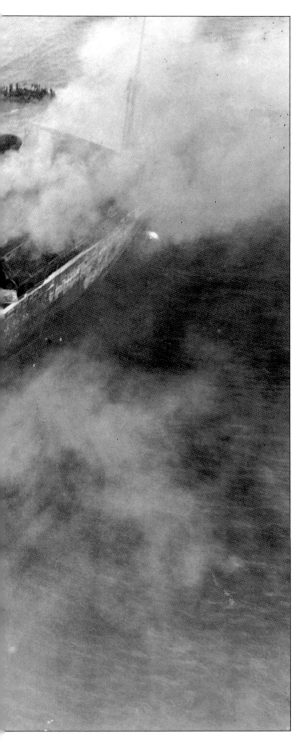

On September 9, 1934, Harry photographed the still-burning Morro Castle from a small plane whose pilot flew him over the ship. Large crowds gathered on the Asbury Park beach to watch the spectacle.

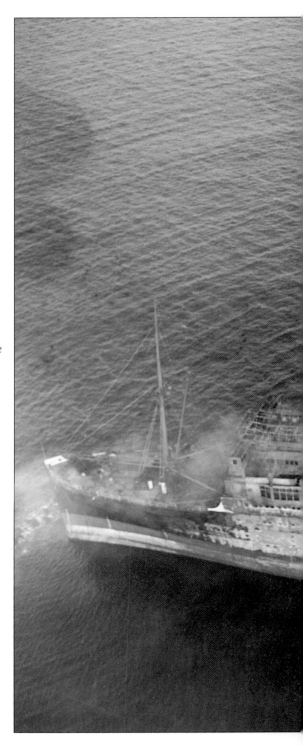

On a subsequent pass over the ill-fated ship, the smoke had disappeared, except for that coming from the ship's smokestack.

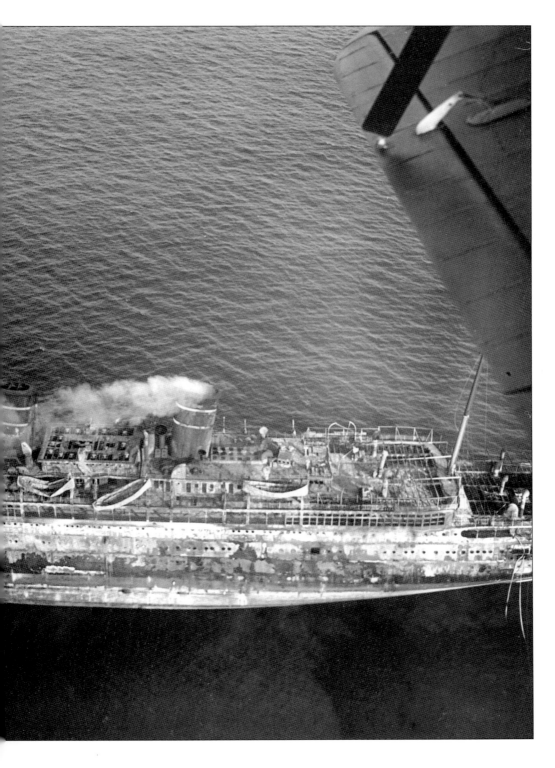

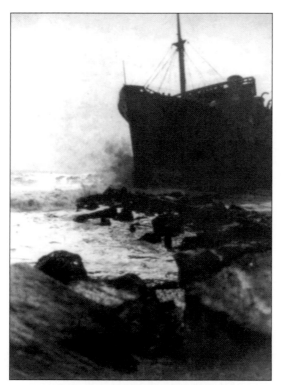

TOP: The Morro Castle's *bow, as dimly seen from the stone jetty in the foreground.*

BOTTOM: *Harry boarded the ship and walked through one of the Morro Castle's ruined decks.*

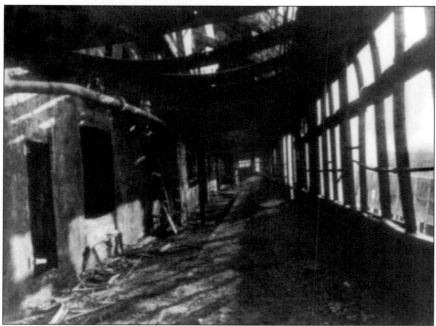

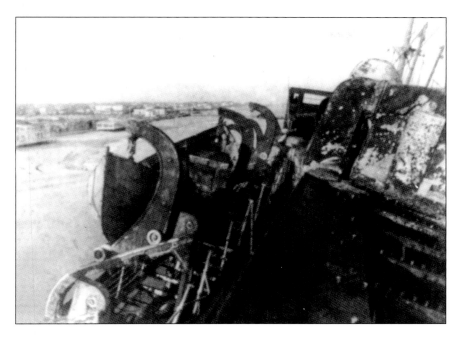

Note that a lifeboat is still in place in the view from the ship's top deck.

Bodies of those drowned washed up on the Jersey Shore and were taken to nearby rescue squad buildings.

Please Sign and Return

Harry Dorer did not rub elbows with great figures in history. Instead, he did something more valuable to posterity: he captured them on film as they passed through or resided for a time in New Jersey. He then sought their autographs, and in a surprising number of instances, succeeded in getting them.

It wasn't easy. He printed three copies, one to be used in the *Sunday Call* or the *Newark News* and two enlargements for his own use. He sent the latter two to his subject, requesting that he or she sign one and return it to Harry. The other belonged to the subject.

It might, of course, have been like throwing paper airplanes into the wind. Who would autograph a photo from a little-known photographer—*and more unlikely, mail it back?*

Herbert Hoover, Al Smith, and Babe Ruth followed instructions, as did Joe Louis, the future king of England, Thomas Edison, and scores of other people in the headlines.

The signers included U.S. presidents Warren G. Harding, Herbert Hoover, and Franklin D. Roosevelt; Mrs. Mary Dimmick Harrison, wife of deceased U.S. president Benjamin Harrison (who died in 1901); Jersey City's famed mayor Frank Hague; several New Jersey governors; entertainer Will Rogers and Metropolitan Opera star Anna Case; New York governor Alfred E. Smith, Democratic candidate for U.S. president in 1928; and G. K. Chesterton, world-famous English author. When Gertrude Ederle, the first woman to swim the English Channel, returned in 1926 to a ticker-tape welcome, Harry photographed her and secured her autograph.

If the notable, just-photographed personage could be expected to remain in the area for an hour or more, Harry might race to a local photographer's studio, where he would develop his negative and print his pictures, then hasten back to the scene. He would get his autograph on the spot.

Most of those who returned the autographed photo at the very least signed them "To my friend, Harry Dorer." Many added further remarks. Elizabeth White, the celebrated agronomist credited with developing the cultivated blueberry, wrote so copiously of her achievements that she almost obscured the bottom of the photo and had to extend her remarks onto the back of the likeness.

Exactly how many of Harry's valuable autographed pictures are in the Newark Public Library collection is not known. After the Dorer gift was accepted, the photos were broken up and arranged by subject.

Here, with no particular order regarding either alphabetical arrangement or the importance of the signer, is a good sampling of Harry Dorer's collection of autographed pictures.

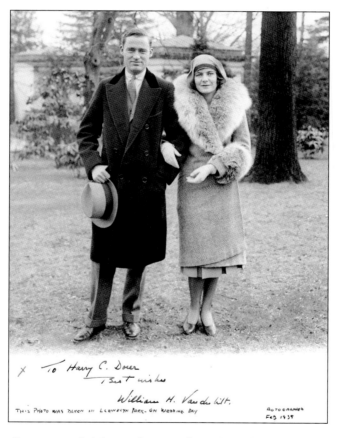

Mr. and Mrs. William H. Vanderbilt, noted New York socialites of the 1930s, were photographed in Llewellyn Park, West Orange, on their wedding day in February 1939.

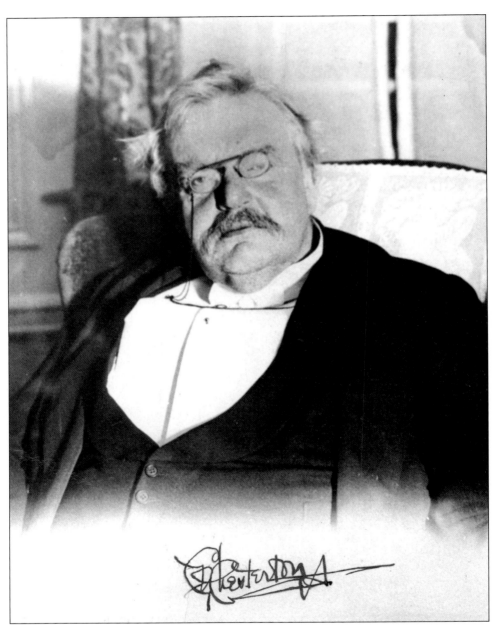

G. K. Chesterton, English essayist, novelist, poet, and critic, was in Newark during a lecture tour.

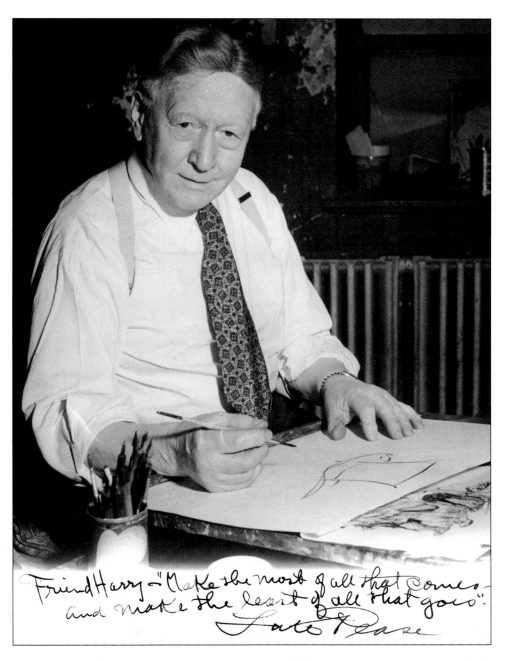

Friend Harry – "Make the most of all that comes, and make the least of all that goes".

Lute Pease

Lute Pease was the Pulitzer Prize–winning cartoonist of the Newark Sunday Call and the Newark News. *He advised Harry to "make the most of all that comes and the least of all that goes."*

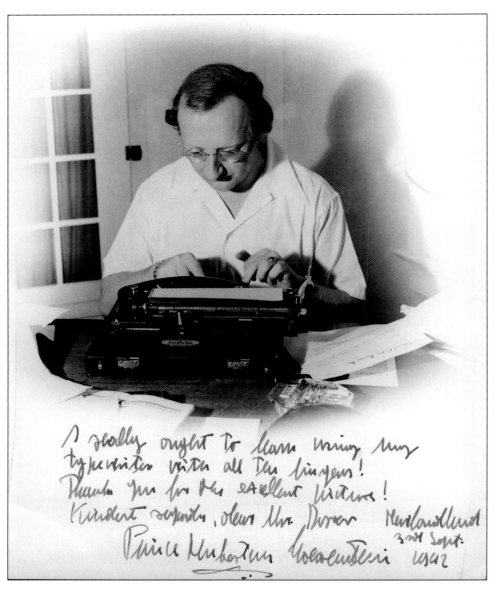

Prince Hubertus zu Lowenstein-Wertheim Freudenberg, leading Catholic layman, was one of the few members of the German nobility to campaign openly in the early 1930s against Adolf Hitler and Nazi brutality. He fled to the United States after the Nazis threatened his life and eventually made his home in Newfoundland, New Jersey, where Harry photographed him in 1942. The prince wrote and lectured tirelessly in the United States against the Nazis and after the war returned home to serve in the new German Parliament. In his salutation to Harry, the prince wished he could learn to type "with all the fingers!"

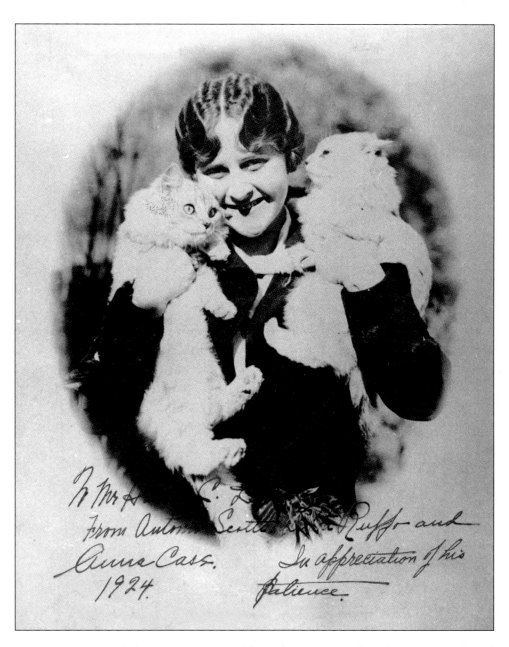

To Mr & ___ C. L. ___
From Anton ___ Sentt ___ Ruff- and
Anna Cass. In appreciation of his
1924. patience.

Anna Case, a native of Clinton, New Jersey, and later a longtime Newark resident, was an acclaimed Metropolitan Opera soprano. At the height of her brilliant career, she retired to marry multimillionaire Clarence H. Mackay, the telephone tycoon.

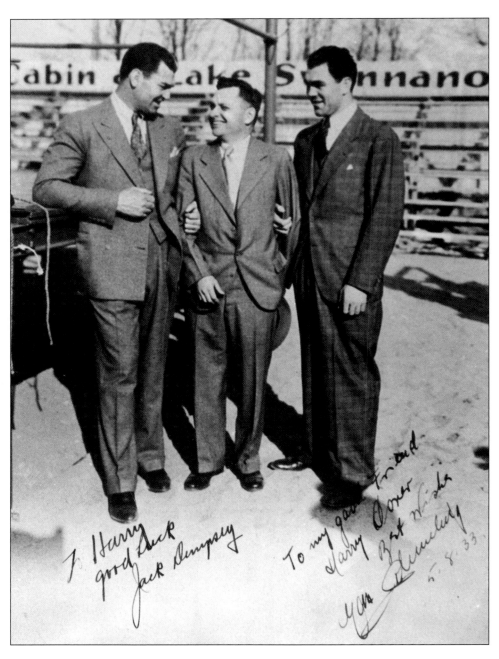

Jack Dempsey (left) and Max Schmeling (right), heavyweight boxing champions, hold Harry tightly between them in this 1933 pose.

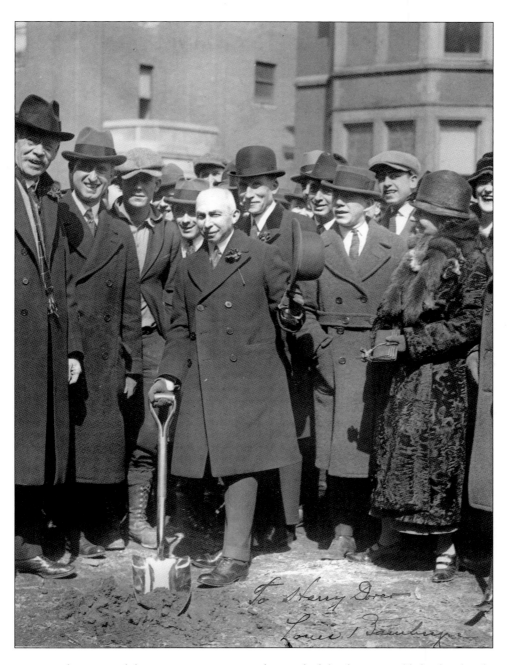

Louis Bamberger, noted department store owner and Newark philanthropist, wielded a shovel at the groundbreaking for the new Newark Museum building in 1926.

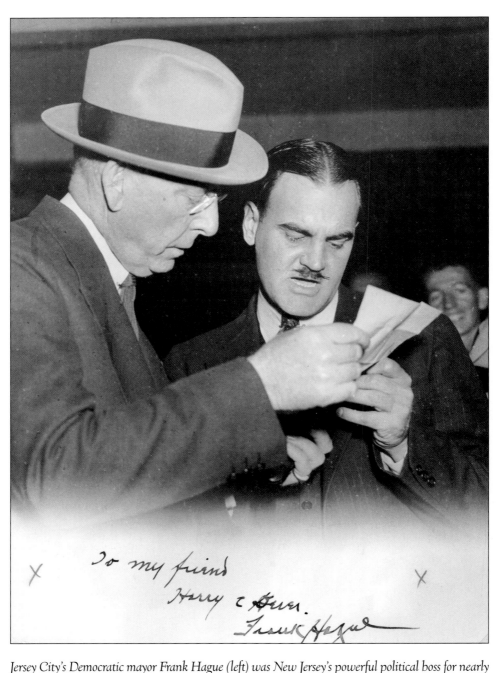

Jersey City's Democratic mayor Frank Hague (left) was New Jersey's powerful political boss for nearly forty years. For three-plus decades his power as a Democratic leader in Jersey City, Hudson County, and the state of New Jersey was strong. Hague's brash declaration, "I am the law," earned him nation-wide publicity and was quoted many times during his life.

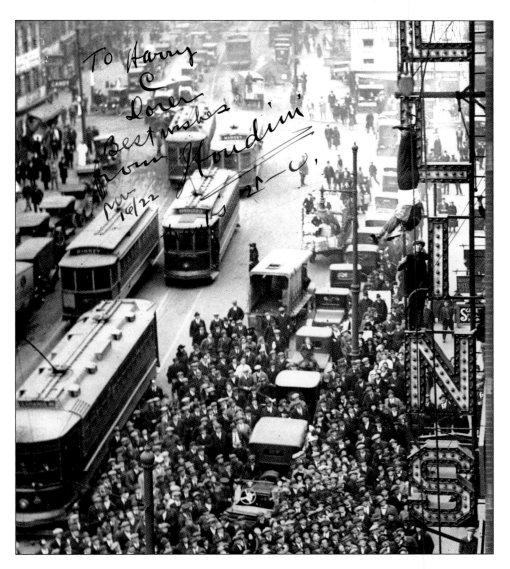

In the summer of 1922, Harry Houdini, possibly the greatest escape artist in history, had himself chained, placed in a bag that was tightly bound, and hauled feet-first to a spot high above Newark's Broad Street (upper right). There, with thousands of spectators watching from the street, Houdini escaped. Later he willingly signed (over the trolley cars) the photo that Harry sent him.

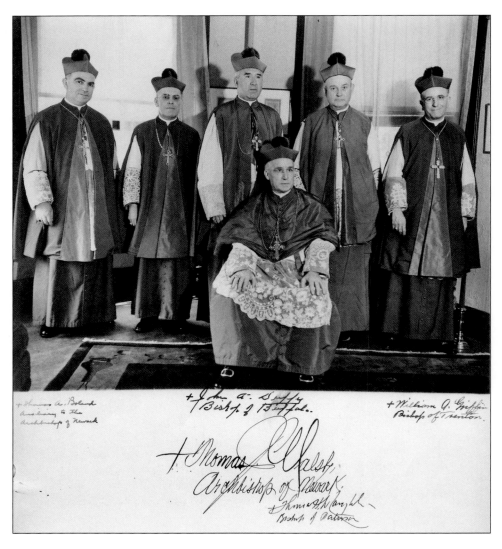

The Ceremony of Consecration on June 29, 1933, of His Excellency Most Reverend John A. Duffy (seated) as bishop of Syracuse. The ceremony was conducted in the Cathedral of the Sacred Heart, Newark. Bishop Duffy sent his autograph, as did Archbishop Thomas Walsh of Newark.

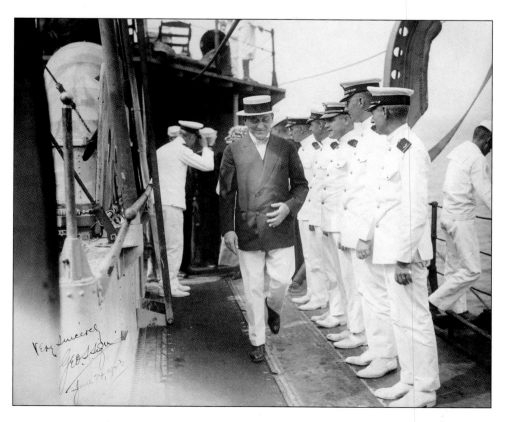

Governor George Silzer commanded respectful attention from officers as he toured a U.S. Navy vessel at Port Newark.

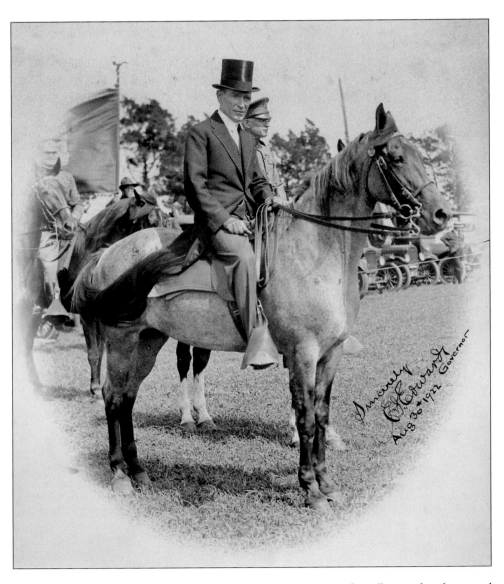

Governor Edward I. Edwards was photographed on August 30, 1922, formally attired and mounted on horse at a military review at the state's "summer white house" at Sea Girt.

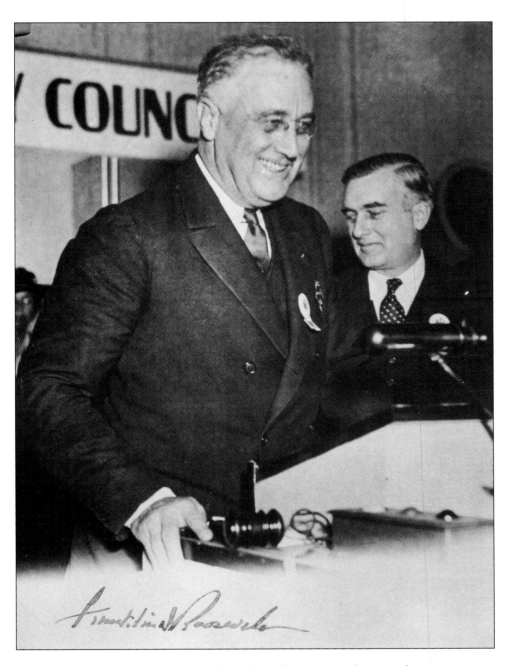

President Franklin Delano Roosevelt, speaking at the Robert Treat Hotel in Newark. New Jersey Governor Charles Edison is to Roosevelt's left.

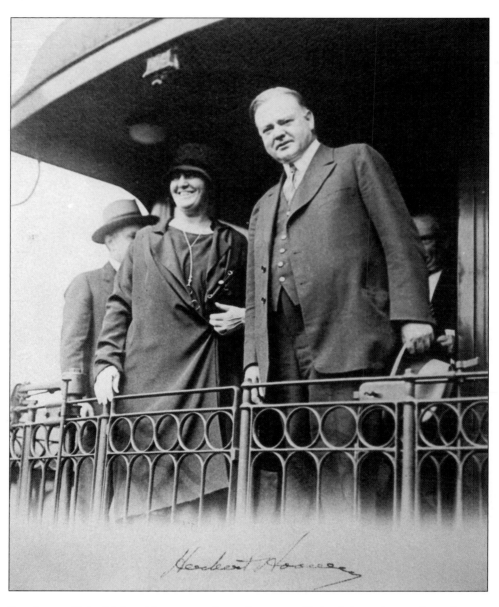

President and Mrs. Herbert Hoover greeted crowds at Newark's South Street Station during his successful 1928 campaign for president.

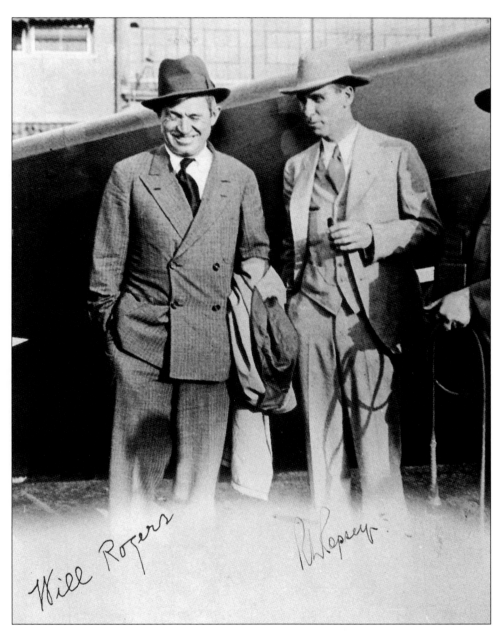

Will Rogers, ever a smiling and witty "country boy" comedian and philosopher, posed during a brief layover at Newark Airport. With him was Major Robert L. Copsey, who often flew Rogers on trips around the United States.

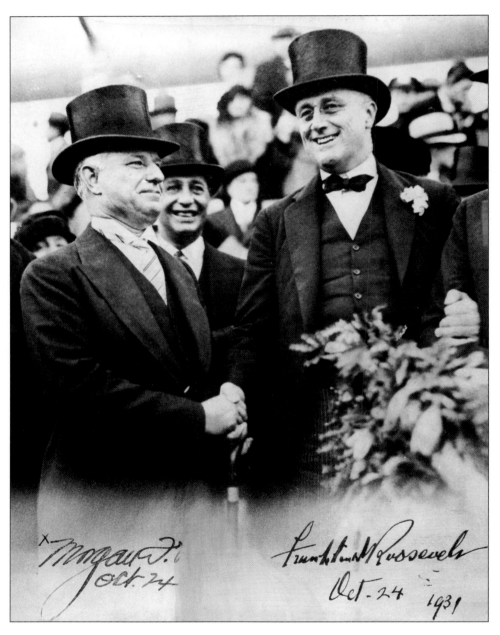

The opening of the George Washington Bridge in 1931 was a happy occasion for New Jersey governor Morgan Larson and New York governor Franklin D. Roosevelt. A mass of photographers made their work difficult. When Harry got into position, Larson was facing away from him. He tugged on the governor's coat and said, "Governor, I am missing this picture." Larson turned around and Harry snapped his photo.

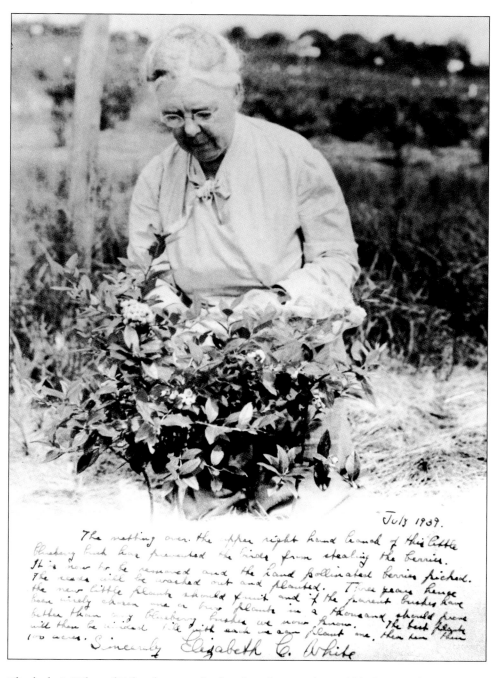

Elizabeth C. White of Whitesbog is credited with perfecting cultivated blueberries. She lived in the New Jersey Pine Barrens all of her life and encouraged pineland dwellers to bring her wild blueberry plants. Along with her signature, she explained her work at length on the back of the photo.

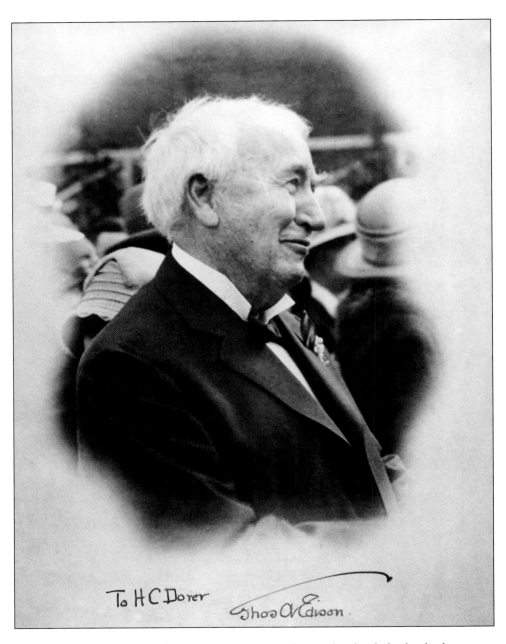

To H C Dorer Thos A Edison.

Thomas A. Edison sent Harry this autographed photograph just a few days before his death in 1931. It was one of the last photos of the inventor, and one of the most widely reprinted. Known for inventing the electric light, the phonograph, and motion pictures, Edison opened his first laboratory in Menlo Park in 1876 and moved to a larger laboratory in West Orange in 1887. He received more than a thousand patents in his lifetime.

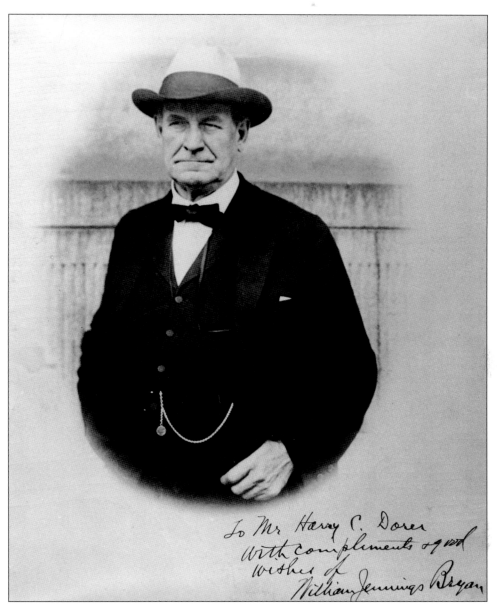

To Mr Harry C. Dorer
With compliments and good
wishes of
William Jennings Bryan

This early Dorer photograph came because of his keen memory. While waiting on a New York pier for the ship bearing the 1924 Olympic team home from Paris, Harry recognized that a nearby man quietly eating an apple was William Jennings Bryan, Nebraska's well-known Democrat congressman and three-time losing candidate for president. Harry asked him if he would pose. Bryan threw away the apple core and stood for his picture. A year later, just before his death, in 1925, Bryan prosecuted the famous trial of teacher J. T. Scopes, who was charged with breaking a Tennessee law by teaching Darwinism.

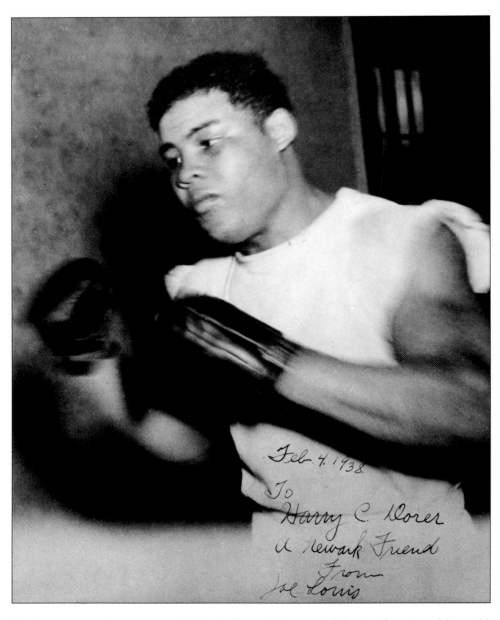

On February 4, 1938, a very young Joe Louis, the superb heavyweight boxing champion of the world, returned his autographed portrait and called Harry "a Newark Friend."

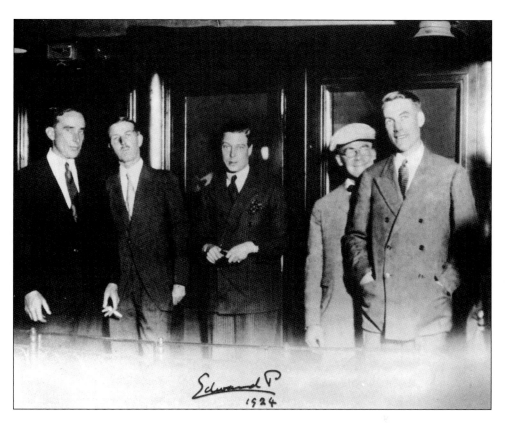

The heir-apparent to the Crown of England, "Edward P" (for Prince of Wales) (center) was snapped during a brief stop in Newark in 1924. When Harry's flashbulbs did not go off on the first or second tries, the prince's aides urged him to leave. Edward ignored them, the flash eventually worked, and this was the result. Harry's two photos caught up eventually with the prince and he rewarded Harry by returning one with the autograph.

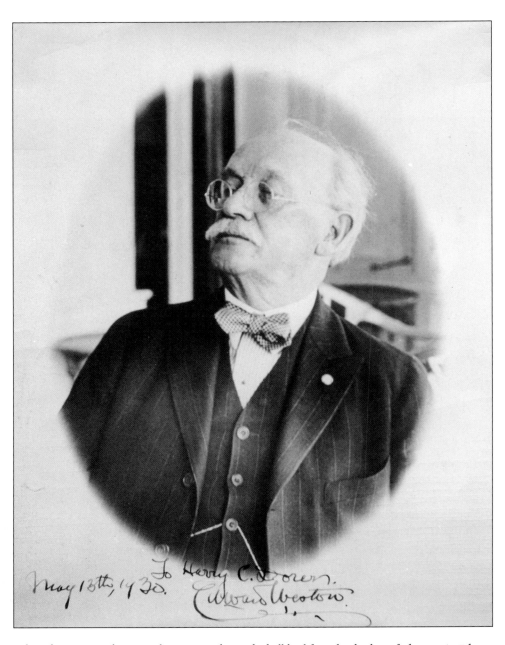

May 13th, 1930. *To Harry C. Doren.*
Edward Weston.

Edward P. Weston, the Newark inventor who worked all his life in the shadow of Thomas A. Edison, lit some of Newark's streets with arc lamps in 1878 and went on to become a noted inventor of electrical meters. He opened a large factory in Newark to manufacture his inventions.

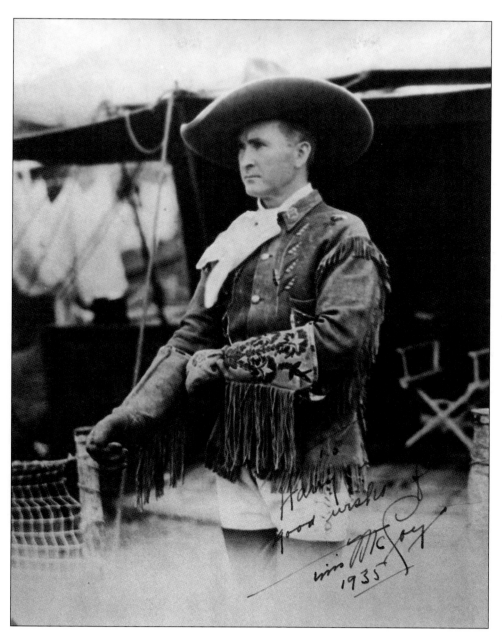

Tim McCoy, the sixty-five-year-old former cowboy and circus entertainer, a candidate for Wyoming state senator in 1942, posed while attending a Newark circus. He extended "good wishes" along with his signature.

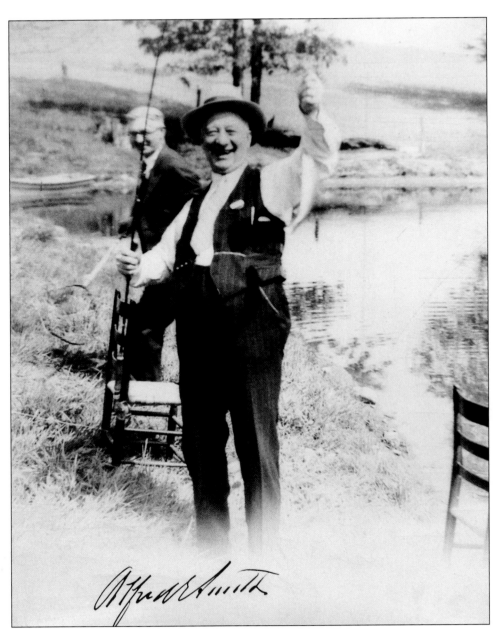

Alfred E Smith

This was a picture Harry was not supposed to get. Hunterdon County hosts of New York governor Alfred E. Smith, long-time New York governor and Democratic candidate for U.S. president in 1928, asked that no photos be taken. Harry persevered and Smith's delight with his catch of a trout overcame his host's objections.

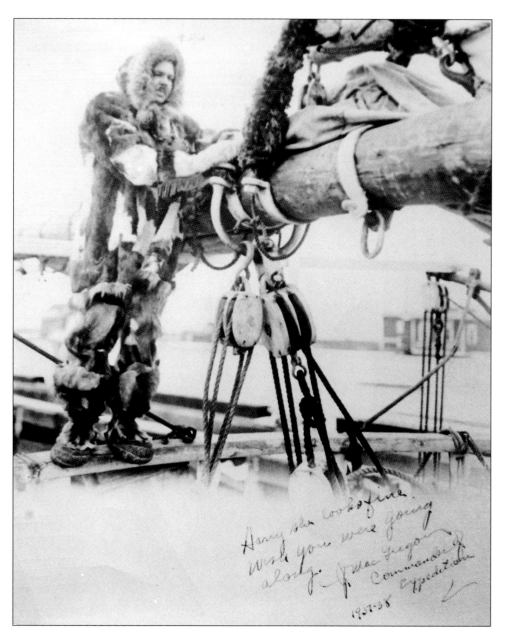

Arctic explorer Clifford J. MacGregor looked over his three-masted windjammer at Port Newark in 1937 and with his signature told Harry that "she looks fine, wish you were going along" on an upcoming expedition MacGregor would head. Harry politely demurred.

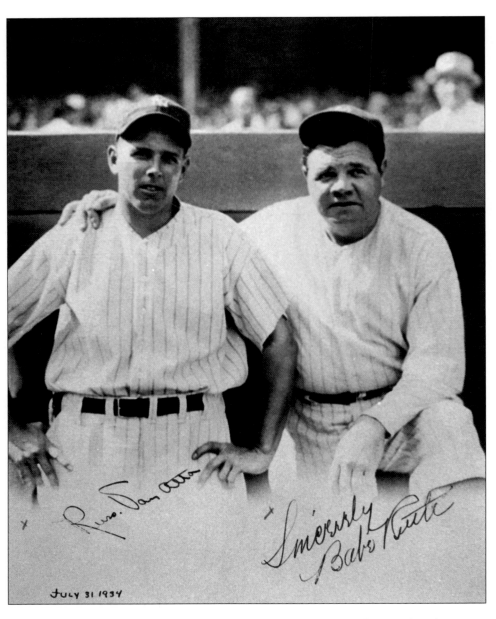

Russ Van Atta and Babe Ruth posed for Harry in the dugout at Yankee Stadium. Ruth and Van Atta, a Yankee pitcher, were close friends as well as teammates. The Babe spent many off-season weekends on Van Atta's farm in Sussex County, New Jersey.

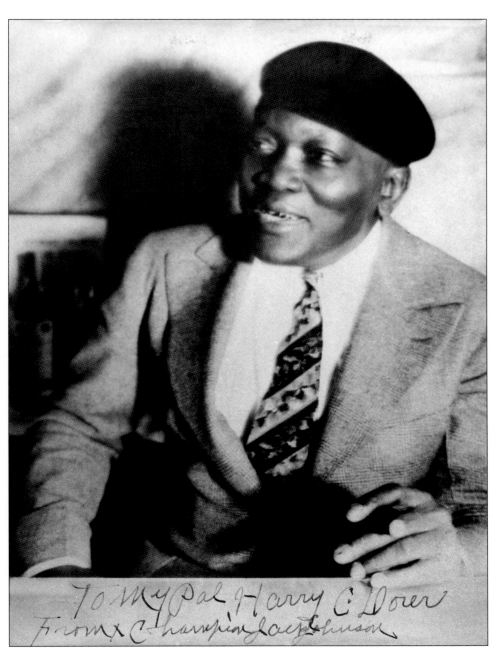

Jack Johnson autographed his portrait to "my pal Harry C. Dorer." Johnson became boxing's heavy-weight champion of the world in 1908 by beating the Australian Tommy Burns. Johnson was considered one of boxing's greatest champions although his enemies (nearly all white) criticized his character and called him "a cheap publicity seeker."

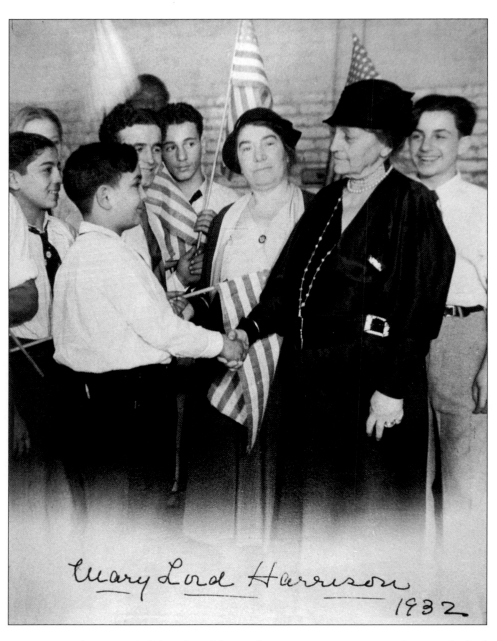

Mary Lord Harrison

1932

Mrs. Mary Lord Harrison (right), widow of the President Benjamin Harrison, visited a Newark school in 1932. Harry photographed her there and sent her this print for her signature. She returned the auto-graphed photo a year later. Harry noted "she said the photo was terrible, but as she had promised, she had autographed it."

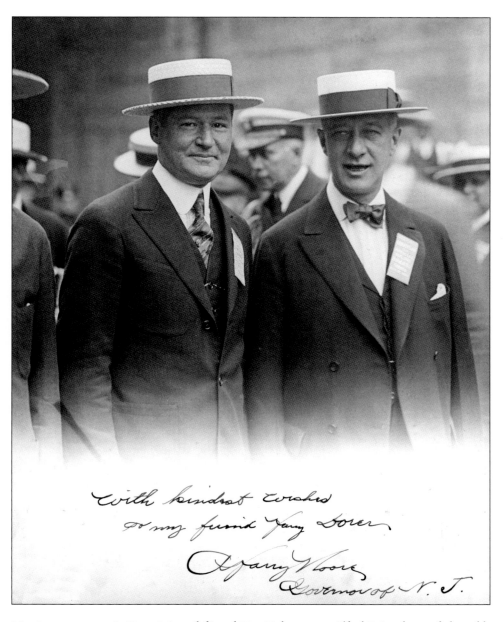

With kindest wishes
to my friend Harry Dover

A Harry Moore
Governor of N. J.

New Jersey governor A. Harry Moore (left) and New York governor Alfred E. Smith wore fashionable straw hats when they posed for Harry.

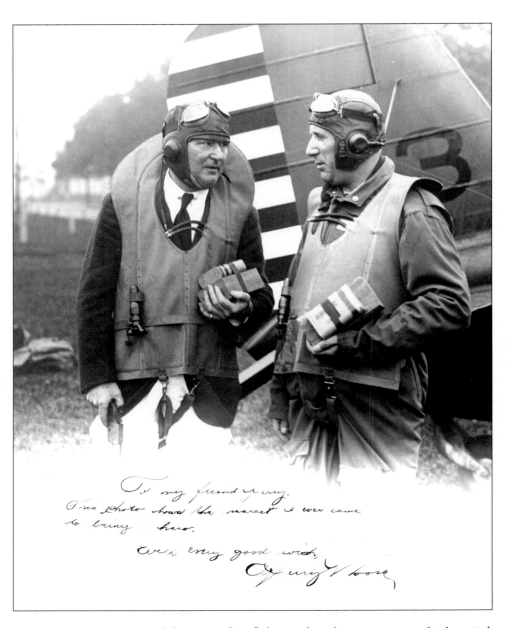

Governor A. Harry Moore, on left, prepares for a flight over the Atlantic Ocean east of Asbury Park in early September 1934. He was directing rescue efforts seeking possible victims of the burning Morro Castle.

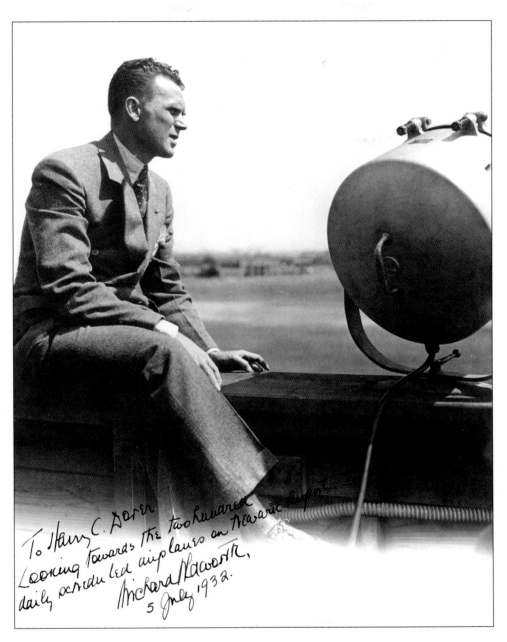

To Harry C. Dorer
Looking towards the two hundred
daily scheduled airplanes on Newark airport.
Richard Aldworth,
5 July 1932.

Colonel Richard Aldworth had a life that read like good exciting fiction. He was a star athlete, a war hero, and an aviation statesman. His goal for Newark Airport was the 1932 message he sent Harry: "I'm looking towards the two hundred daily scheduled airplanes at Newark Airport." He died in 1943, with many of his dreams fulfilled.

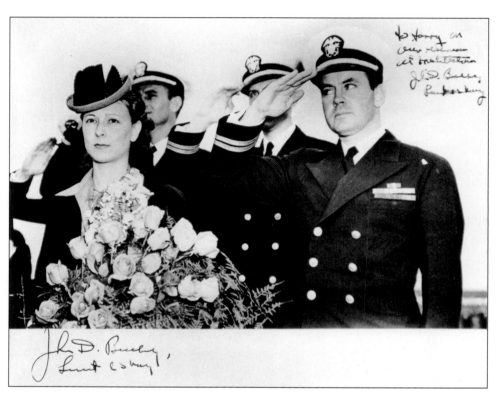

Lieutenant and Mrs. John D. Bulkley of Hackettstown salute the launching of another U.S. Navy P51 vessel. Bulkley had won honors for his brilliant use of the small attack vessel in the waters off the Philippine Islands.

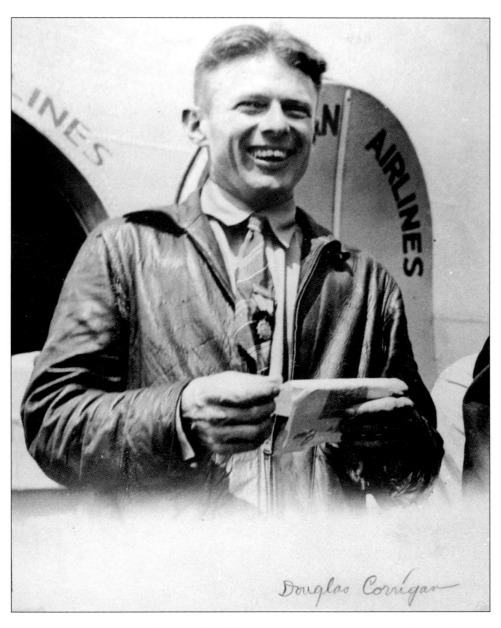

Douglas Corrigan

Douglas Corrigan, known as "One Way" or "Wrong Way" Corrigan, was photographed at a banquet held in Newark in his honor. In 1938, Corrigan had taken off on the way to Long Beach, California, and made (he said) a wrong turn. The next thing he knew he was flying over the Atlantic Ocean headed for Europe. The reception accorded Corrigan on his return from his tongue-in-check flight equaled the praise heaped on Charles A. Lindbergh.

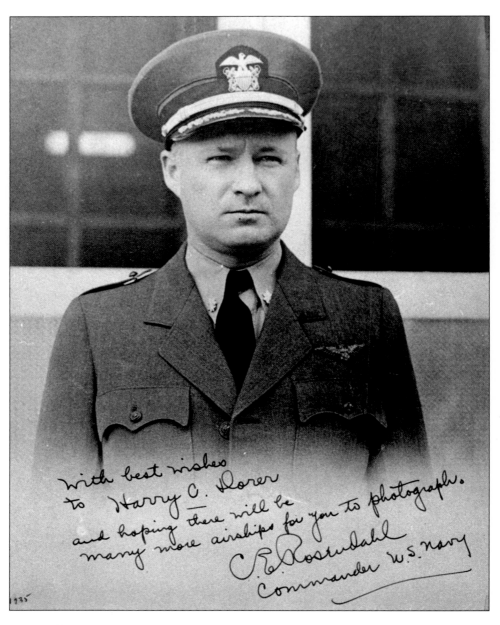

With best wishes
to Harry C. Dorer
and hoping there will be
many more airships for you to photograph.
C. E. Rosendahl
Commander U.S. Navy

1935

Commander C. R. Rosendahl, chief officer at the Lakehurst Naval Air Center during the days when history was being made with lighter-than-air craft, such as blimps and the great ocean-crossing dirigibles.

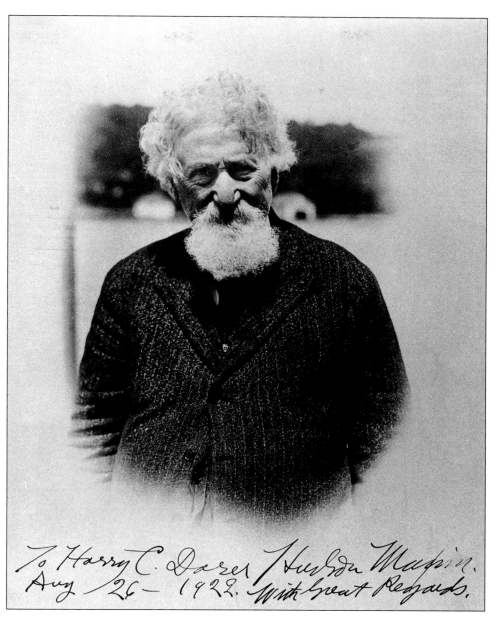

To Harry C. Dorer / Hudson Maxim.
Aug /26 — 1922. With Great Regards.

This rare picture of Hudson Maxim, the engineer charged with the responsibility of decommissioning the old Morris Canal, was taken in 1922 at his Lake Hopatcong home. Maxim is best remembered as the inventor of smokeless powder.

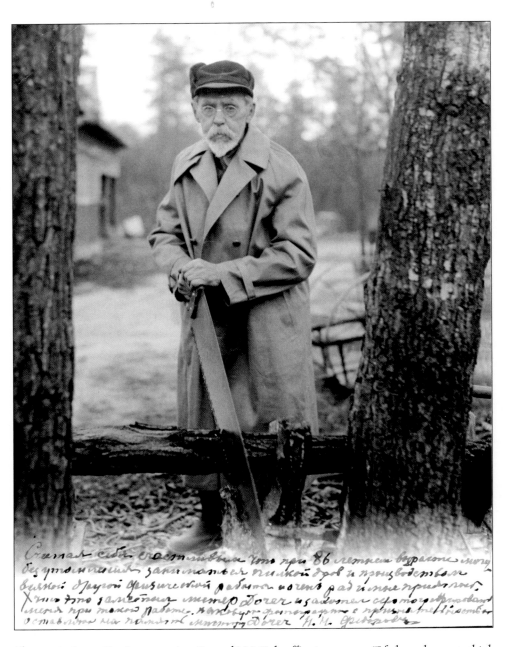

The inscription on Russian expatriate General N. J. Federoff's picture notes: "I feel very happy to think that a man of my age of 86 years can without becoming tired, saw wood, and do other physical work. I am glad that Mr. Dorer noticed my work and was so thoughtful to take my picture when I was sawing wood."

Governor Alfred E. Driscoll's greatest work was steering the 1947 Constitution Convention from start to finish. Driscoll immediately put into effect the vigorous antidiscrimination laws created in the new constitution.

The Joys of Childhood

WHERE WERE New Jersey's ready smiles, joy, and surefire appeal wherever a photographer looked? Harry Dorer knew the answer: wherever the children were. It could be anywhere—down on the farm or on city streets; faking a knockout in a city gym or playground; playing between rows of cornstalks or cooling down on a hot summer day when a hydrant was opened. Harry knew that when kids gathered, they forgot their differences and put aside their handicaps.

Perhaps your grandfather or grandmother was in the crowd waiting to get on that bus to go to summer camp for a magical escape from reality. Perhaps a relative lined up with the roller skaters. Perhaps he or she even posed for Harry as a child.

Few images in the *Newark Sunday Call* or the *Newark Sunday News* were more enjoyable than a Dorer photo-essay on children being children. In the 1920s and 1930s boys and girls were children for a much shorter time: city children often were working in factories or mills before age fourteen. Farm boys more often than not attended school until they could be considered full-time, full-grown farmhands—most certainly by age sixteen.

FACING PAGE:

TOP: *Bill Leimer, head of Bill Leimer Boys League of Orange, welcomed a crowd of Essex County boys and girls to the bus headed in 1943 for the League's summer camp at Lake Musconetcong.*

BOTTOM: *Leimer greets two somewhat apprehensive campers and advises them to be active in his camp if they want a fine summer experience.*

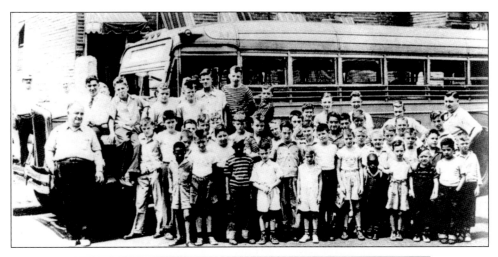

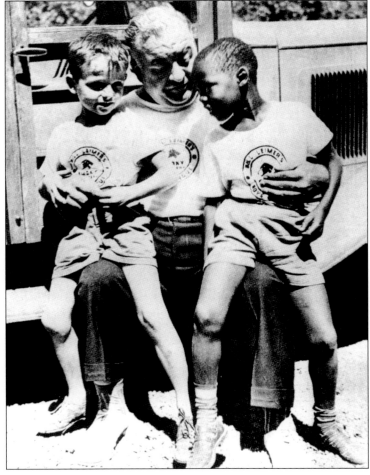

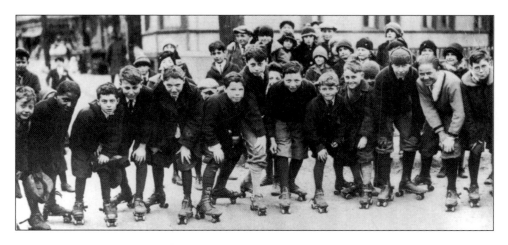

These boys didn't need a bus; they zipped over the streets of the cities and small towns on roller skates. Note that the skates are the old-fashioned "screw on" type.

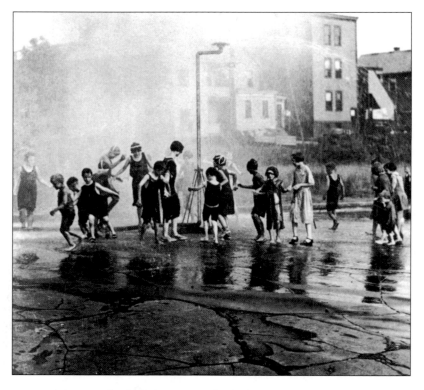

Kearny didn't wait for the kids to open a fire hydrant illegally on hot days. They set up a special sprinkler to cool off the boys and girls. A few children wore bathing suits but many jumped under the spray in regular clothes.

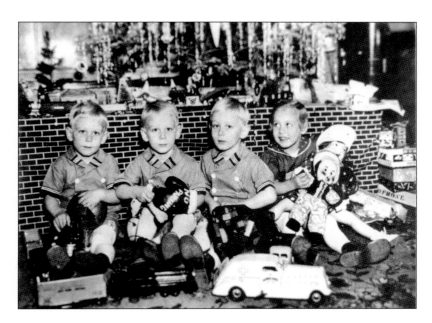

The most noted children Harry photographed were New Jersey's "Kasper Quads," born on May 9, 1936, to Elsie and Emil Kasper of Clifton. Harry visited the famous four in December 1939. They celebrated their fourth Christmas with three somber faces and one smile from the only girl among them.

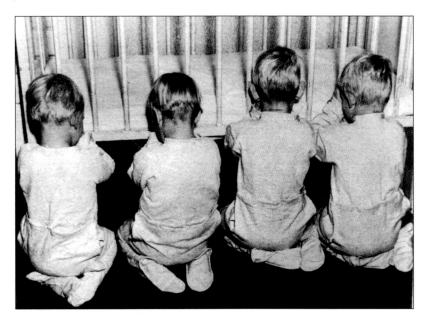

Bedtime meant four prayers rising simultaneously from the quad's bedroom.

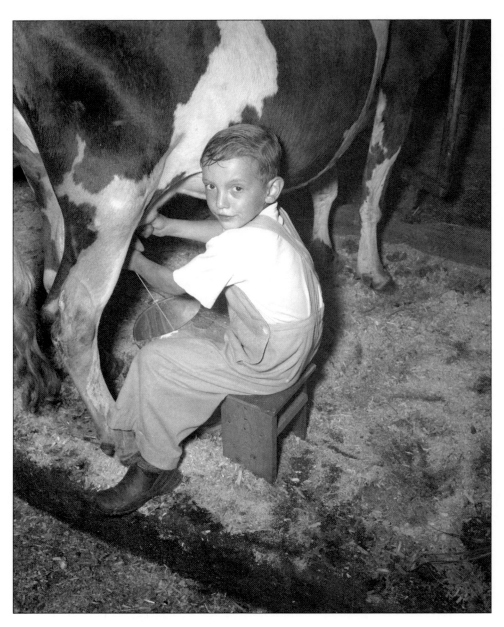

Harry's very young neighbor showed his skill in milking a cow in the family's barn in then-rural Livingston.

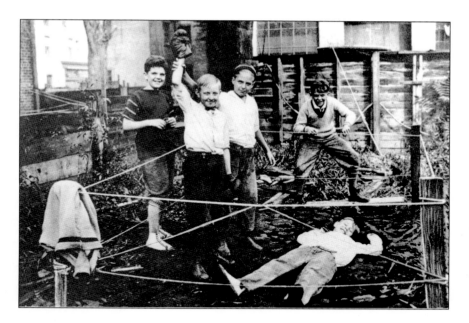

In an age when Jack Dempsey was focusing attention on boxing, this group of young sportsmen staged a bout in their tiny backyard ring. The winner smiled in triumph. Even the loser had a broad smile.

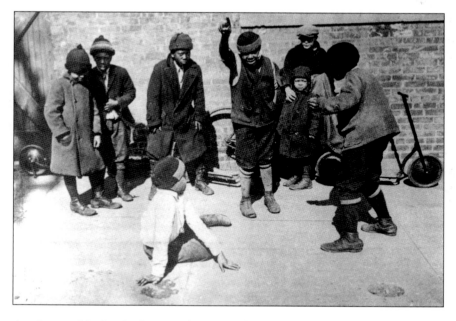

Another neighborhood "championship" was decided in a bare-knuckle bout. Harry assuredly staged this "fight."

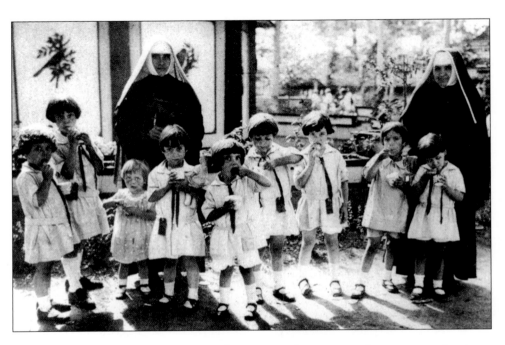

Children from the Saint John the Baptist orphanage enjoyed ice cream on their 1929 annual outing at Olympic Park in Irvington.

FACING PAGE: *One of the thousands of children entertained in 1929 at the Holy Name Society's annual children's day at Olympic Park was only mildly amused by the park's popular diminutive cop.*

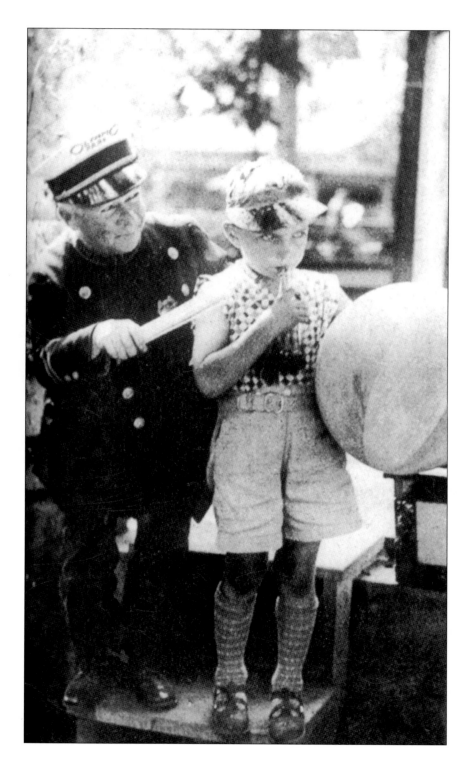

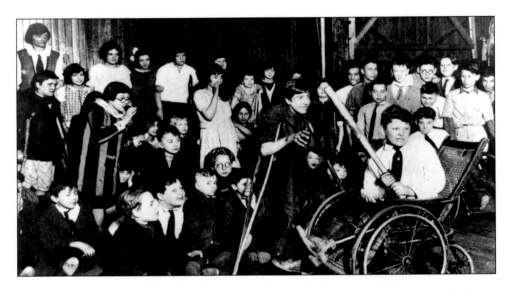

Wheelchair baseball is not something new. Handicapped children from Belmont Avenue and Alexander Street schools in Newark played this game in 1925.

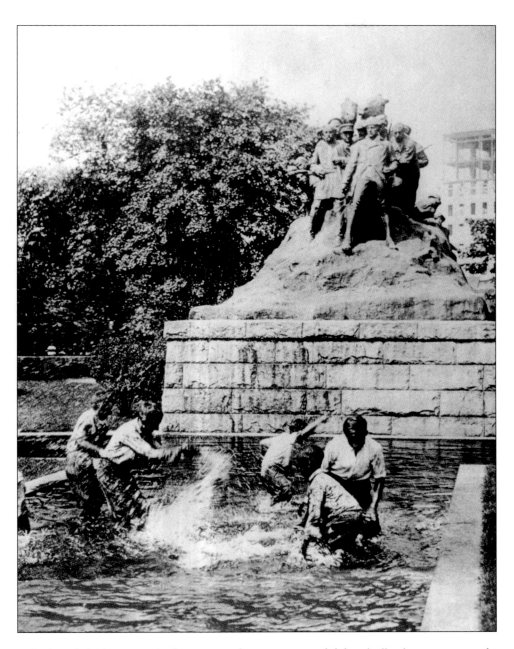

Fully dressed children enjoyed a few minutes of impromptu—and definitely illegal—swimming in the lagoon of the Wars of America monument in Newark's Military Park.

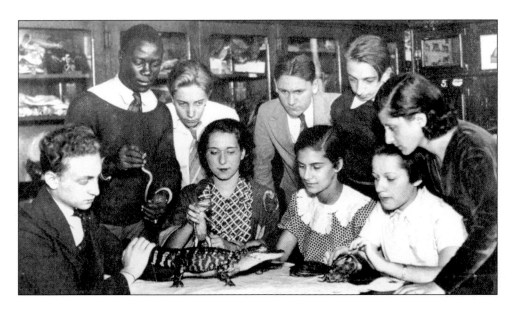

Students at Newark's Weequahic High School were fascinated by a small reptile shown by their teacher. Note that the male students wore neckties.

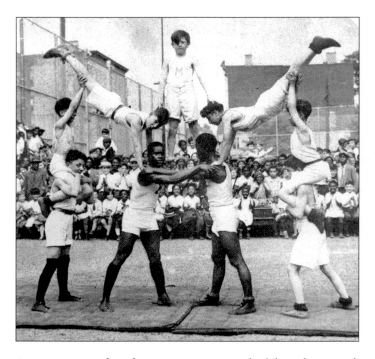

A gymnastic team from the Montgomery Street School showed its strength and its skill in a performance before a large audience of schoolchildren.

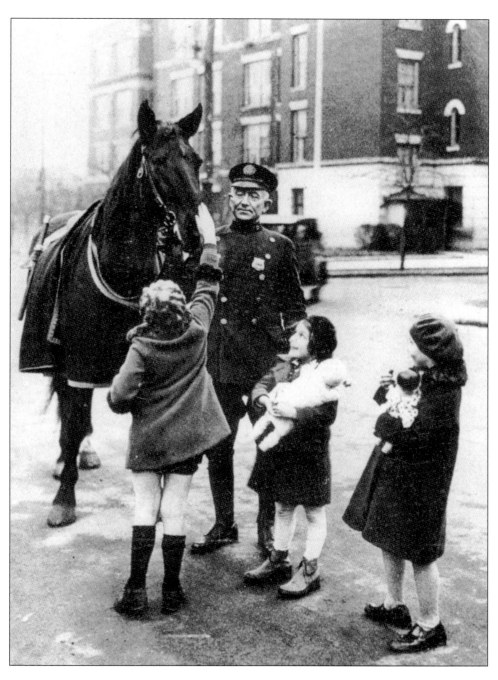

Could any day be brighter for Newark children than meeting a mounted policeman who let them reach high to pat his horse's nose?

CHAPTER SEVENTEEN

Animals Demanding Attention

Here are some of Harry Dorer's animal friends, mostly posed as if they were humans. Usually they seemed to enjoy the attention—at least to the point of not moving while the camera snapped and a flash lit up the scene. The only true victims would be a flock of turkeys, benignly unaware the calendar foretold that Thanksgiving was just around the corner.

As far as dogs were concerned, the "World Series" of dogdom was staged each May on the estate of Mrs. Geraldine R. Dodge in Madison. Harry was there, of course. It didn't seem possible that the great Giralda Farms dog show would ever fade away. In 1935, when Harry visited the spectacle, it was called the "largest dog show in the country." But World War II ended the affair.

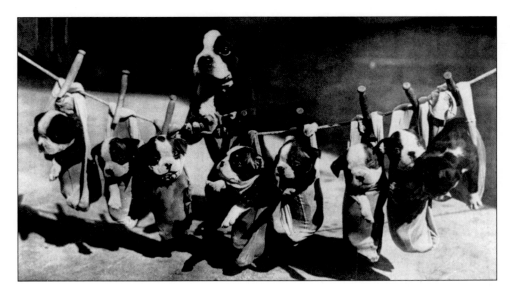

Eight brother and sister pups, hung out to dry. Their proud father stood behind his offspring.

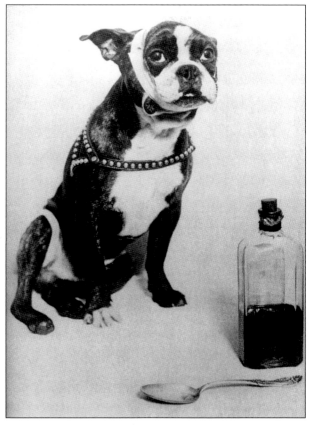

On second thought, according to Harry, the proud dad was sick with worry. Eight pups!

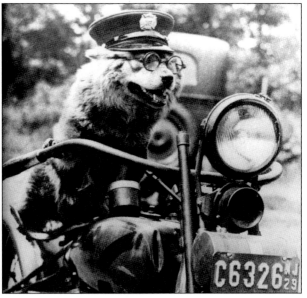

The Livingston Fire Department's mascot, dressed up as a police chief. No one started the motorcycle for him.

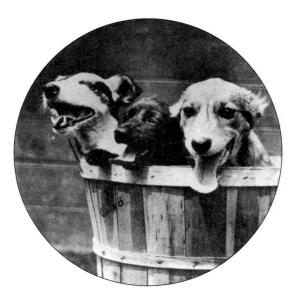

A peach basket made a cramped and unwelcome prison for three complaining dogs.

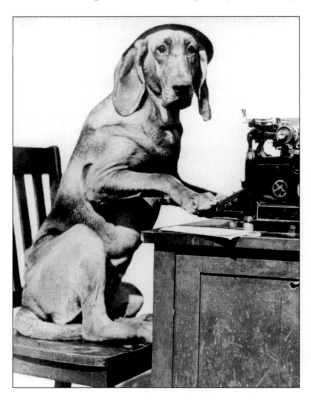

"Lady Winchester" tapped out her daily humor column.

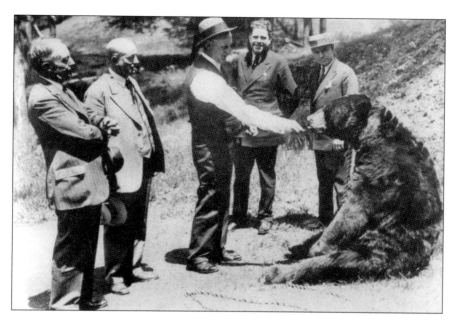

Fortunately for his human admirers, this tame circus bear had a good disposition.

*Harry put an up-to-date 1928 calendar page on a pedestal on a west New Jersey turkey farm.
The approach of November 22 did not seem to dismay any of the turkeys.*

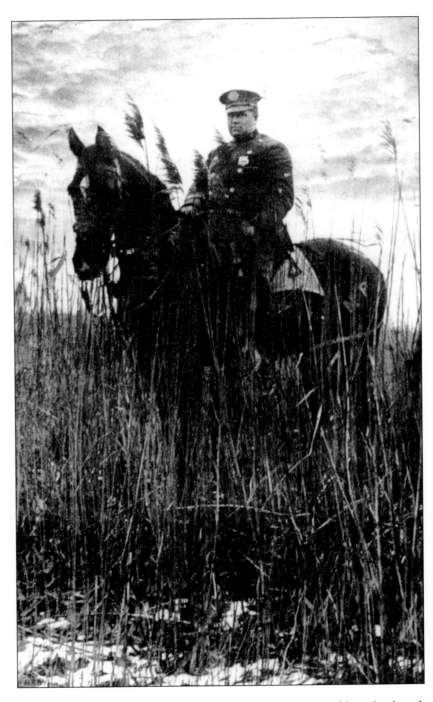

One of the horses assigned to a Newark mounted policeman carried his rider through the swamps and tall grass on the eastern edge of the city.

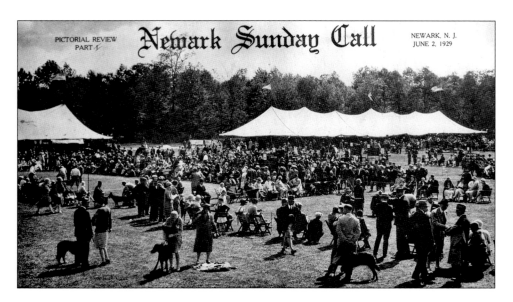

Newark Sunday Call

Nothing pertaining to animals matched New Jersey's most spectacular dog extravaganza during the Great Depression—the annual show that took place on the Geraldine R. Dodge estate in Madison. This perspective emphasized the judging area, the most important place to be.

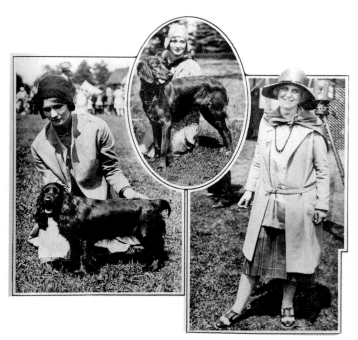

A montage featured Mrs. Dodge, on the right, and two winners in their classes and their owners.

ANIMALS DEMANDING ATTENTION | 211

The War Draws Near

EUROPE'S WAR came ever closer to the United States as the Nazi war machine reached awesome power. German submarines became active along the Jersey Shore and often sank oil tankers and other vessels. Navy blimps stationed at Lakehurst flew regular patrols from Cape May to Long Island, seeking to spot the U-boats.

New Jersey shipyards dramatically stepped up production at Kearny and Newark; the two shipyards combined to make 22 percent of all U.S. Navy destroyers and turned out a finished ship every 4.5 days.

The powerful long-range guns at Fort Hancock practiced for an invading armada, casting shells at targets many miles across the waves. Colleges and universities began training men for a war they were doomed to fight. Women entered jobs long denied them.

Then, on December 7, 1941, Japanese planes attacked Pearl Harbor. The world, and New Jersey, would never again be the same.

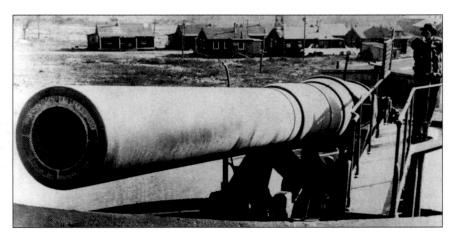

Day after day in the late 1930s, the big guns of Sandy Hook could be heard, preparing to guard New York Harbor if the need arose.

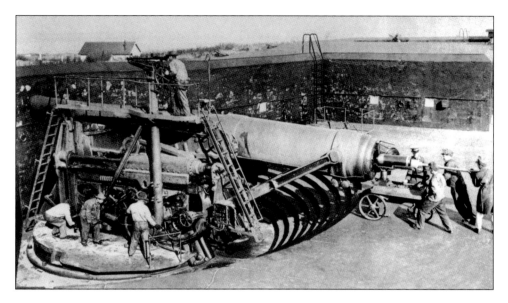

Heavy shells were loaded into the long-range weapons, the gun was elevated, and it fired the round at targets floating many miles away in the Atlantic Ocean.

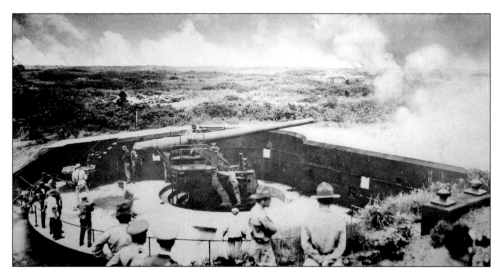

After firing, the gun's emplacement receded into a pit, an aid to hiding the weapon's existence.

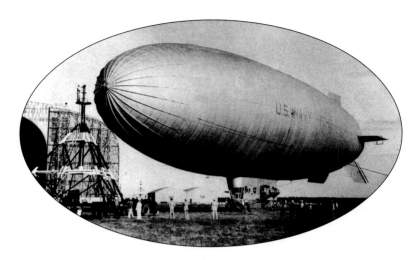

Harry Dorer rode on one of this blimp's surveillance flights along the shore, with German U-boats the possible quarry.

The noiseless lighter-than-air ride gave Harry a chance to photograph Atlantic City and its nearly deserted beach.

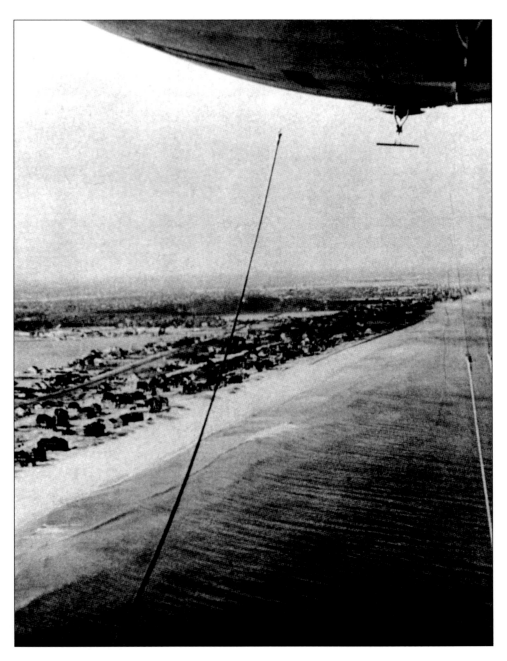

Farther north, the blimp glided silently above Bay Head. Whether any U-boats were seen could not be told. Harry was sworn to secrecy.

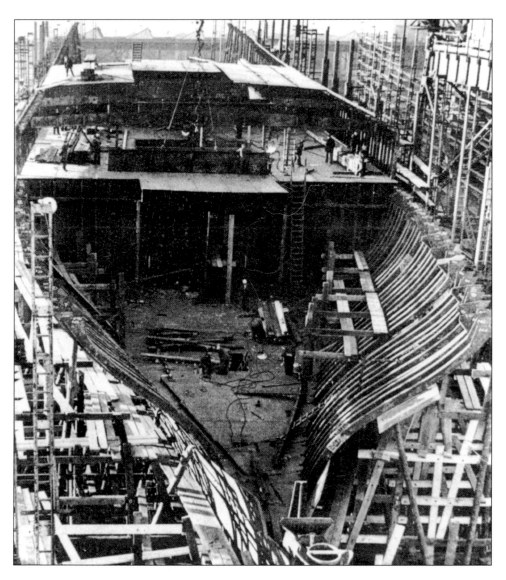

Shipbuilding picked up enormously at Kearny's shipyard, where hulls of new ships were being laid at an astounding rate.

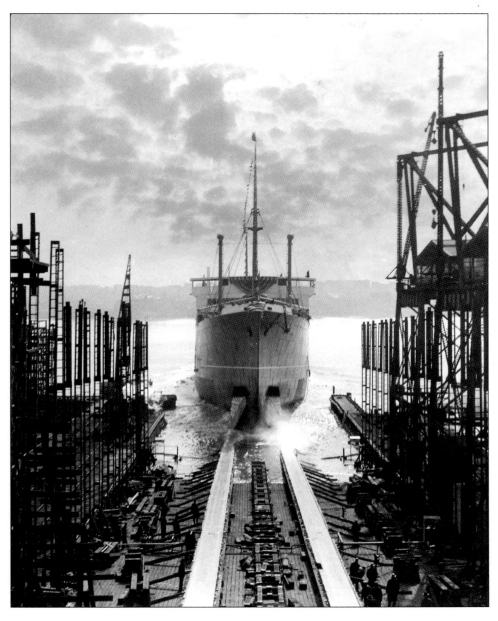

Ships slid down the ways, sometimes several in a day, as the war effort went into high gear.

As young men went away for basic training, civilians were urged to plant Victory gardens. Governor Charles Edison showed the way by planting potatoes in his front lawn.

Gasoline was in very short supply, so a Livingston man built his wife this pedal-powered gas-saver that hauled both the baby and the groceries.

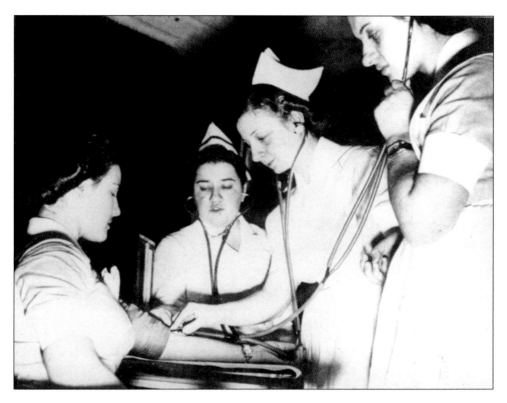

Hospitals stepped up their training of nurses. Every candidate memorized the various surgical instruments. A sophisticated teaching tool permitted three student nurses to read blood pressure simultaneously on one patient.

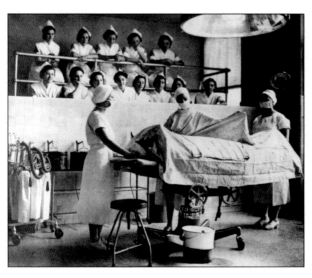

Student nurses intently watched the pre-operation procedures, where skilled nurses taught the steps in preparing a patient.

The severity of the war in England received closer attention and increased support when British sailors and other allies came to New Jersey for rest and relaxation. After months at sea this sailor hoped this fowl might soon be a cooked goose.

Under supervision from his host, a sailor "raided" the refrigerator.

Sailors visited old Tennent Church, where the Battle of Monmouth swirled about the doors on June 28, 1778.

British sailors were fascinated by the Princeton Battle monument, commemorating January 3, 1777, when some of their ancestors took a good drubbing.

The Brits also took a fancy to America's young women, which won them no friends among their American peers.

Getting Ready for Over There

T HE BOMBS OF Pearl Harbor sent millions of men and women into uniform. Students at Newark University (a predecessor of Rutgers University in Newark) prepared to enter the U.S. Army and other branches of service. Training began with teaching about sophisticated instruments and progressed to flying small biplanes as preparation for eventually flying fighter planes or bombers.

Already in the Army Air Corps were Lieutenant Francis Schroth and fellow officers who were testing an eighty-five-pound camera in Newark.

Harry Dorer visited Fort Dix to photograph New Jersey men in service. He called the Fort Dix training "a melting pot," where civilians from all walks of life and all professions were blended into the ever more powerful war machine.

Appropriately enough, Harry also visited Pennsylvania Station to observe soldiers on the move from base to base. America was getting ready.

Preparing to fly began in a Newark University classroom, where an Army Air Corps officer introduced students to the problems and opportunities in service.

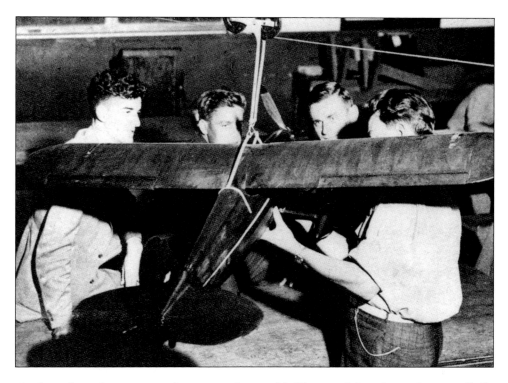

Familiarity began by exposing students to a working model of the type of plane they might eventually fly.

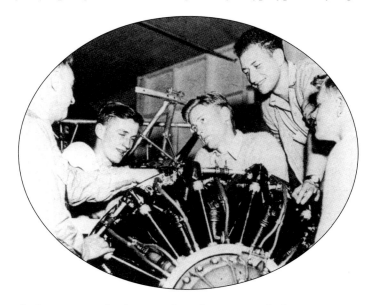

Air Force men had to recognize that knowing their planes intimately, from motors to wing flaps, was absolutely necessary.

Flight training would begin in a biplane with two seats, one for the student, the other for the teacher.

Pilots-to-be were put through an intensive study of the weapons they would be using in their flights against an enemy.

A special project at Newark Airport involved experiments with a new type of surveillance camera that weighed sixty-five pounds.

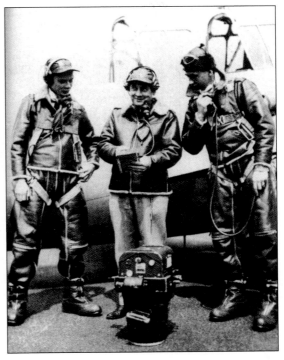

Air Corps Lieutenant Francis Schroth demonstrated how the "Big Bertha" could shoot obliquely (at an angle) from the side of the plane rather than only from the usual vertical position in an opening in the bottom of the plane.

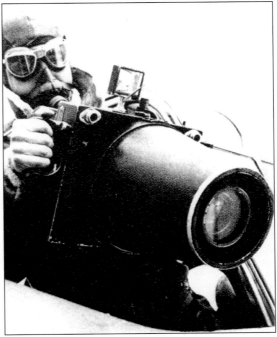

Harry visited Fort Dix to photograph the process of turning civilians into soldiers. He labeled this trio, comprising two waiters and a barber, as part of the "melting pot."

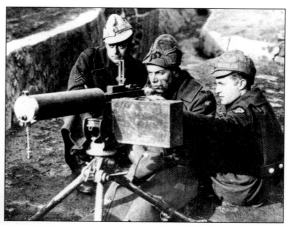

A corporal who had a master's degree in teaching from Columbia University showed rookie soldiers how to use new weapons.

A former postman and a lifeguard teamed up to become experts in handling a deadly 60-mm. mortar.

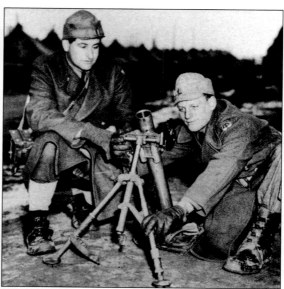

A Newark sergeant learned how to sew a damaged parachute.

Trainees quickly set aside civilian pursuits for such things as night maneuvers with large artillery pieces.

This dramatic photo demonstrated that soldiers had at least a partial understanding of what it meant to be under fire.

Soldiers were everywhere: Harry found many waiting for trains at Newark's Pennsylvania Station. Here is one shining his shoes—a must for a recruit aiming to stay in good grace.

FACING PAGE: *Discipline was important. One of the tallest military policemen on record, Corporal Knuckles, six feet, six inches tall, easily kept order among soldiers waiting for trains.*

Finally all the sham battles and tests and target practice came to an end. The orders had come for service overseas.

Left behind were the mothers who had sent their sons to war. As the soldier leaves, his mother weeps. The three blue stars in her window meant she already had three sons in uniform with another star about to be added.

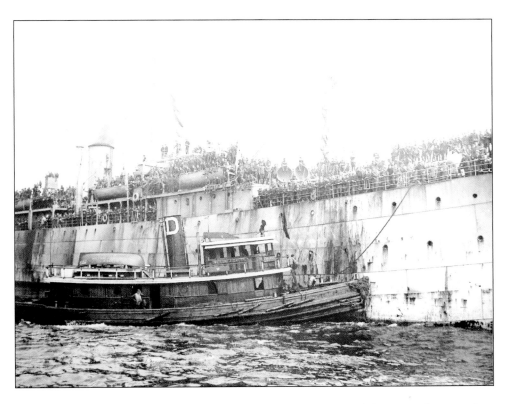

Relief, mixed with fear, swept through the soldiers on deck as a tug moved their troop ship away from its dock and pointed it eastward to where World War II was raging.

Women Go to War

WHEN PEARL HARBOR ensured that the United States would enter combat in World War II, Harry Dorer set out to see how New Jersey's young women were reacting. He found a large contingent of women working on the Pennsylvania Railroad. They maintained and ran machines once ticketed "Men Only," shoveled ballast, repaired tracks, and ate their lunches accompanied by the roar of passing trains. The army's vast and ever-growing supply depot at Belle Mead needed them as guards and equipment repairpersons. Harry also found women in the Red Cross, the Civil Air Patrol, and recruiting for the Women's Army Auxiliary Corps (WAAC). A woman's place was no longer in the home: she was in the ranks.

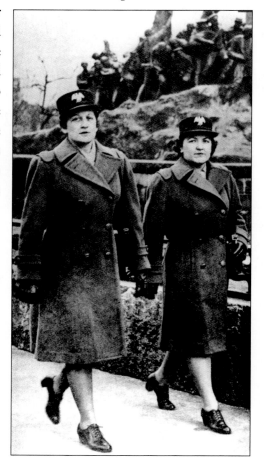

Uncle Sam needed everyone to help. These recruiters were seeking women to serve in the women's branch of the U.S. Army.

At about the same time, two young women were doing "men's work" for the Pennsylvania Railroad.

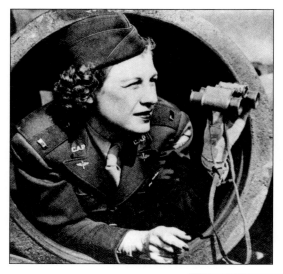

A watcher for the Civilian Air Patrol searched the skies for anything that might need to be reported.

Back on the railroad, two female workers shoveled heavy ballast to support the Pennsylvania's tracks.

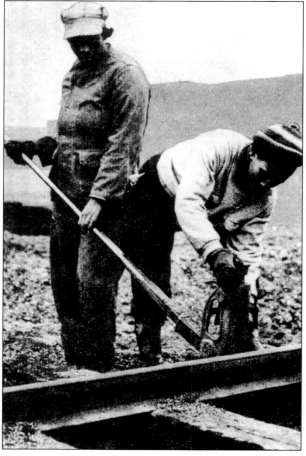

This company guard was well qualified to carry that high-caliber pistol: she could hit 95 out of every 100 shots.

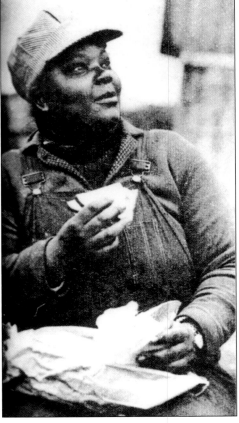

Lunch hour was just that for a railroad worker, who brown-bagged the meal to save money and to get a few minutes rest.

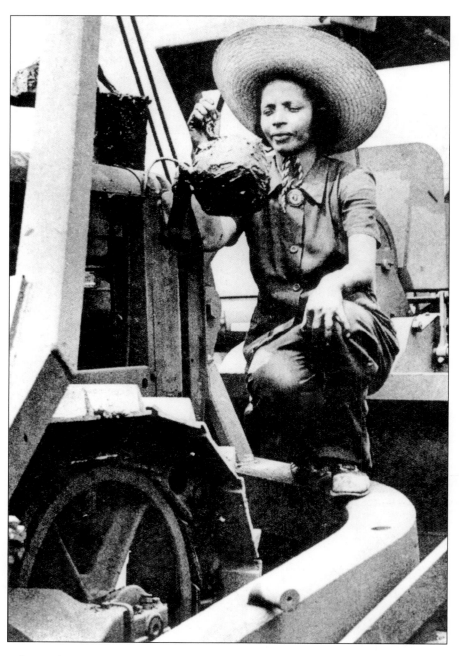

Belle Mead Army Depot needed help and got it from this young woman, whose sombrero protected her from long days in the sun.

FACING PAGE: *Another woman painted a piece of huge equipment at Belle Mead.*

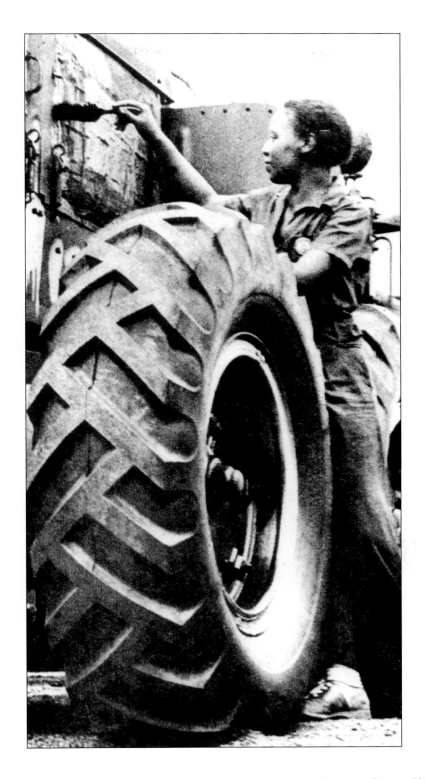

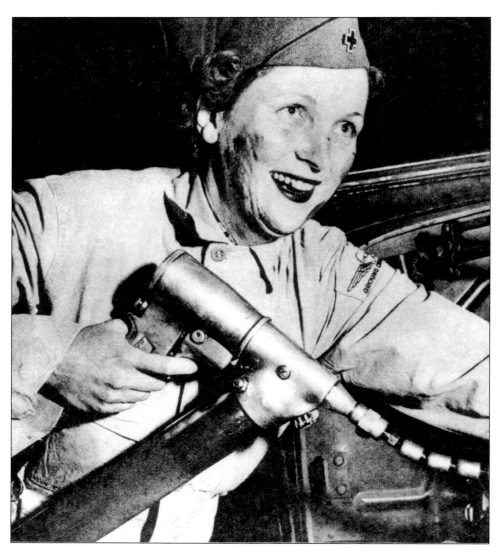

Red Cross volunteers helped take up the slack by helping to service their own vehicles.

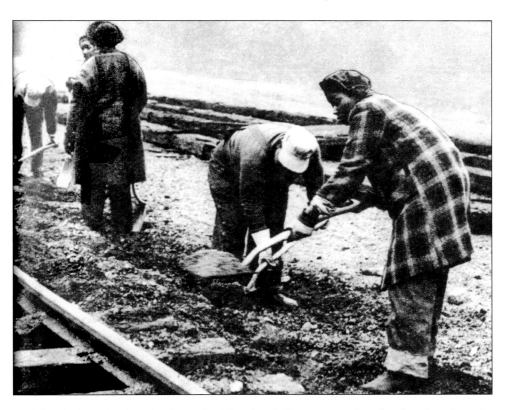

Back beside the railroad tracks, the work of shoveling ballast went on day after day, throughout the war.

ABOUT THE EDITOR

JOHN T. CUNNINGHAM has been hailed by the New Jersey Historical Commission as the state's "most popular historian." After working as a reporter for the *Newark Evening News,* he teamed up with Harry Dorer on the *Newark Sunday News Magazine* to write a travel series called "Let's Explore" in 1947. He published his first book, *This Is New Jersey,* with Rutgers University Press in 1953, and has published several other books with the Press over the decades. In addition to writing books, Cunningham has written numerous magazine articles and has produced about twenty documentary films. He has been awarded nine honorary degrees by New Jersey colleges and institutions and has earned four Awards of Merit from the American Association for State and Local History.